IMAGES
of America

DALY CITY

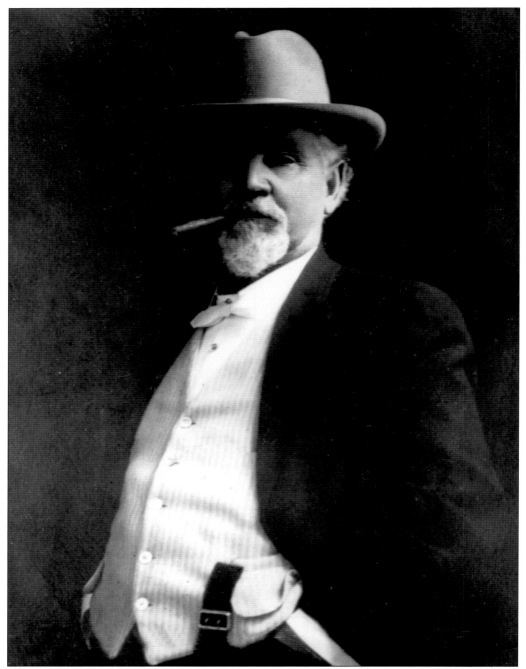

JOHN DONALD DALY. Looking every inch the successful rancher and businessman that he was, John Daly lived a rags-to-riches 81-year life. During his 55 years in Daly City (1868–1923) he contributed much of his energy, interest, time, talent, and money to the development of the area's quality of life. He did not seek the distinction, but politely accepted in 1911 when residents voted to name their new city in his honor. (Courtesy of DC/C HG collection, donated by Henry Sundermann.)

IMAGES
of America

DALY CITY

Bunny Gillespie

ARCADIA
PUBLISHING

Published by Arcadia Publishing
Charleston SC, Chicago IL, Portsmouth NH, San Francisco CA

Printed in the United States of America

Library of Congress Catalog Card Number: 2003112412

For all general information contact Arcadia Publishing at:
Telephone 843-853-2070
Fax 843-853-0044
E-Mail sales@arcadiapublishing.com
For customer service and orders:
Toll-Free 1-888-313-2665

Visit us on the Internet at www.arcadiapublishing.com

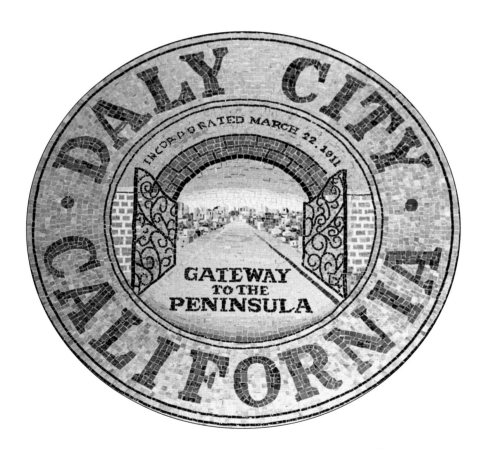

DC's Official Logo. Executed in multi-colored pieces of ceramic tile, this representation of Daly City's emblem, unveiled at the dedication of the Civic Center on May 30, 1969, is displayed in DC's Council Chamber. (Courtesy of DC/C HG collection.)

CONTENTS

Acknowledgments 6

Introduction 7

1. In the Beginning: Before 1910 9

2. The Hospitable Mountain: 1911–1940 31

3. Drama on the Mountain: 1941–1960 65

4. The Mountain Welcomes: 1961–1985 91

5. The Mountain Remains: 1986–2003 and Beyond 115

ACKNOWLEDGMENTS

This book could not have been completed without patient encouragement, prodding, meticulous research, and countless contributions by our dear darling spouse of over half a century, Ken Gillespie, whose cheerful demeanor is our constant bulwark and inspiration.

Prior to 1911, all of northern San Mateo County was known as Colma. The origin of that name is moot. Some say it was from a youngster passing through aboard a train. Supposedly he/she poked his/her head out of the cozy conveyance and said to an accompanying parent, "Gee, it's cold, ma!" Others assume that Colma is a corruption of the name of the gold mining area of Coloma. Either story is smilingly acceptable. Acknowledgment of historic Colma is imperative.

This book of images spans development of the Daly City area. While every photo might not be the most definitive, we have tried to share some visual remembrances of years and people.

Especially acknowledged is John Donald Daly, the rancher for whom Daly City was named. We thank Mr. Daly, and all the other pioneers that helped to bring the quality of life enjoyed today in Daly City.

With special affection, we acknowledge the saving ways of Lillian D. Fletcher, who was a first-class pack rat when it came to things historical. Many of the photos in this book are from her private collection, bequeathed to us, (the Gillespie collection). We dedicate this book to her.

Next we acknowledge historical materials gathered by former Daly City librarian Sam Chandler in prelude to creation of his 1973 book *Gateway to the Peninsula*. His research photos became the nucleus of the Daly City/Colma History Guild (DC/C HG) collection.

Gratefully, we acknowledge people who have donated vintage photos and information from family scrapbooks, shoeboxes, files, lock boxes, and so forth to the history guild for display and research under the purview of the guild and its volunteer historians.

We also thank dear friends, some designated in photo captions, that have given the author family photos, documents, certificates, letters, and other items of historical and nostalgic value to supplement our role as historian for the City of Daly City (by action of the city council on September 23, 1987). Ours is a process of continuing education, which is truly a labor of love and enjoyment.

If we have failed to give credit where credit is due, we apologize. If you are in possession of photos that would have, could have, or should have been included in this book, we would appreciate hearing from you. We are always looking towards publication of our next book. Thank you for your consideration and interest in preserving the history of the area.

INTRODUCTION

Daly City was voted into incorporation in 1911 by an underwhelming but decisive count of 138 to 136. Almost 100 years later, some residents were still debating those election results and hoping for assimilation into the city and county of neighboring San Francisco. Proximity to the premier city of Northern California gives Daly City a unique amount of residential desirability.

Located just seven miles from the heart of San Francisco, Daly City is the most northerly community of San Mateo County. Much of Daly City, known as the "Gateway to the Peninsula," (if heading south, and "Gateway to San Francisco" if heading north) occupies long-previous Spanish land grants, primarily the ranchos Laguna de la Merced and Guadalupe la Visitacion y Rodeo Viejo.

The highest point of the area's hilly terrain is San Bruno Mountain (elevation 1,314 feet) from which members of Gaspar de Portola's exploratory party achieved initial sighting of San Francisco Bay in 1769. A few Native Americans lived, hunted, and foraged on the mountain. In 1776, when Spanish missionaries passed through the natural gap between the mountain and low coastal hills, they called the pass La Portezuela. The road leading north from other settlements was dubbed Mission Road, and its general location has changed little since Spanish days.

Mission Road, now known as Mission Street, still forks at what is now known as Daly City's "Top of the Hill," with one road leading to Mission Dolores in San Francisco and the other to the Presidio of San Francisco. While other locations down the San Francisco Peninsula were being settled, very little was happening in La Portezuela. The soil wasn't very receptive to crops, and it wasn't until after California's celebrated Gold Rush that any interest was paid to open spaces west of San Bruno Mountain.

Those arriving in the later years of the 19th century joined a pioneer population of migrant and immigrant farmers and ranchers that had been spearheaded in 1853 by farmer Patrick Morgan Brooks and Robert Sheldon Thornton, a blacksmith. Thornton was a native of Rhode Island. Born in Ireland, Brooks was naturalized in Massachusetts.

Both young men had spurred their steeds south from San Francisco after the United States government allowed purchase of land between San Bruno Mountain and Lake Merced. Brooks, then 28, settled at the base of San Bruno Mountain in a fertile valley that was to become incorporated as Colma (in 1924). Thornton, 31, settled on the sandy northwest coast of San Mateo County before acquiring additional property to the east. Both put down roots and saw their holdings and fortunes improve vastly.

They were followed by other pioneers who brought skills and families to the area. Predominantly of Irish descent, these settlers established homes, businesses, farms, and ranches. Some had sought gold in the California diggings of 1849, without much, if any, success. They proceeded to cover the land with vegetable and potato patches, and San Francisco provided a ready market for their crops.

Prosperity was enjoyed for almost a decade, until an agricultural blight daunted the Irish. They sold out to people of German heritage, who didn't do much better. Their enemy was the natural "air-conditioning" of the area, better known as fog. The dampness became intolerable for many settlers, but not all. As the discouraged put their homes and land up for sale, families

of Italian background tried their skills at developing properties. New seeds and heartier crops were introduced. They brought artichokes, cauliflowers, beets, carrots, sprouts, cabbages, and other produce to the landscape, as well as flowers such as dahlias, lilies, violets, strawflowers, mums, and marigolds. Plows pulled by sturdy horses were guided between tidy rows of field crops, and the area began to thrive again. The Italians were successful.

In 1856, as the population increased, Thornton and Brooks established Jefferson school on land donated by pioneer Peter Dunks. The one-room building was the first of the Jefferson School District. The name of the district remains unchanged. Over the years, descendants of the pioneering Irish, German, and Italian families have continued to be highly involved with the area's social, economic, political, and business communities.

In 1859, a moment of national historical fame occurred near Thornton's first business enterprise, close to the south end of Lake Merced. Two well-known politicians engaged in a pistol duel that some still consider the first shots fired in reference to the forthcoming 1861–1865 American Civil War. Participants were United States Senator David Broderick and former California Supreme Court Chief Justice David Terry. The incident followed a period of insults over the prospective role of California as a free or slave state. Broderick was mortally wounded in the duel, and he died three days later at what is now San Francisco's Fort Mason. Adverse public reaction to his death kept California on the free side of the slavery issue. Broderick's funeral was one of the largest ever seen in San Francisco. Terry slinked off to Sacramento and lived on, mired in unique shame.

As Thornton was settling in the north county in 1853, a 13-year-old lad named John Donald Daly left Boston by ship with his mother, bent on crossing the Isthmus of Panama to find fortune in San Francisco. His mother died during the arduous journey. John continued alone. In 1856, the teenager found work on a Peninsula dairy farm, observed well the techniques of the business, married the boss's daughter, and in 1868 acquired 250 acres at the Top of the Hill area. His San Mateo Dairy ranch barns were among the largest in northern San Mateo County, and prosperity was his. Later his holdings became part of the Borden Dairy Delivery Company. Daly's prowess as a businessman, political mover and shaker, civic leader, and friend to his neighbors followed him all the days of his life.

In the early 1860s, a railroad chugged past Daly's Ranch. Stores, hotels, butcher shops, and other businesses blossomed in the area, as well as St. Anne's Catholic Church (later Holy Angels), a new school, and a railway station. By the 1890s streetcars ran from San Francisco to the city of San Mateo, stopping at "Daly's Hill." Daly had moved his family into San Francisco in 1885 for better schooling, but maintained his local interests, developed a bank, and donated funds for the first local public library.

John Daly subdivided his ranch property in 1907. Housing tracts emerged in the surrounding area. Cemeteries, now banned from San Francisco, opened in the neighboring Colma area. The movement toward incorporation as a city was underway, but many farmers feared city-style taxes and fought against the issue.

Daly City became a city on March 18, 1911, just one month shy of the fifth anniversary of San Francisco's disastrous 1906 earthquake and fire. As the ashes cooled in San Francisco, refugees flocked to the welcoming slopes of San Bruno Mountain, Daly's Hill, and other outlying areas such as the Crocker, Vista Grande, Hillcrest, Mission, and the West End Homestead. Fortunes and homes had been lost in the rubble of the city, and many of those most affected by the catastrophe intrepidly moved their families and salvaged possessions to the south and squatted. Prominent among those that welcomed the survivors was cattle rancher John Donald Daly, in whose honor the city would later be named. Many opted to stay in the area and rebuild their lives. Thus was born a city.

Today, Daly City and Colma are compatible neighbors, forever linked geographically, though not politically or economically. Each is a unique entity, subtly symbiotic and each an important part of the upper Peninsula community.

One

IN THE BEGINNING
BEFORE 1910

While considering real estate in Daly City, a prospective buyer specified, "The house must have a view of The Mountain, preferably in the morning." An erstwhile realtor naively queried, "What mountain?"

Generations of Daly City residents have lived "in the shadow of the mountain that commands the scene around," as local lyricist Ken Gillespie wrote in 1962. The most prominent natural landmark of north San Mateo County, San Bruno Mountain rises to a height of 1,314 feet, is over seven miles long, and is never shy about displaying its year-round grandeur. It was a landmark for centuries before its summit was pierced with a series of electronic beacons and communications enhancers, and long before garlands of residences were strewn along its slopes.

In the mountain's shadow many small real estate developments began to dot its base in the late 1800s. The developments were known as Vista Grande, Sand Hills, Crocker Estates, School House Station, the $75 Homestead, Daly's Hill, and Colma. The name most encompassing for the northern part of San Mateo County, however, was Colma.

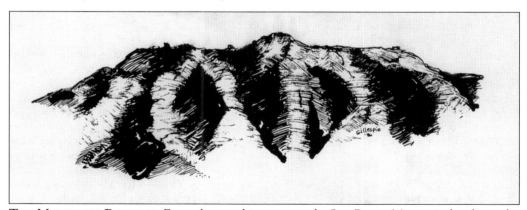

THE MOUNTAIN BECKONS. For as long as history records, San Bruno Mountain has been the dominant landmark for the area now known as Daly City and Colma. Bruno Hecata, a member of Gaspar de Portola's 1769 scouting party, achieved his first sighting of San Francisco Bay from its slopes, and named it after his patron saint. Indian paths had been etched into the terrain over countless years. The mountain today indicates "home" to people who enjoy its beauty and find comfort in its constancy. (Courtesy of Gillespie collection, art by Ken Gillespie.)

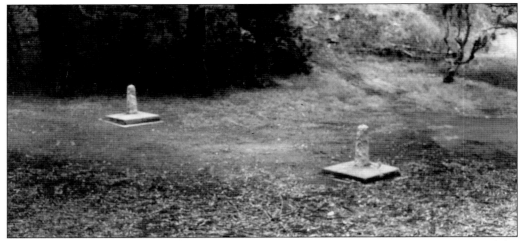

PYLONS MARK THE SPOTS. Placed many years later are these twin historical reminders of the September 13, 1859, duel of honor fought in a wooded field that eventually would become part of Daly City. The event pitted United States Senator David Broderick against David Terry, former chief justice of the Supreme Court of California. Both fired at the count of three. Broderick's gun misfired. Terry's bullet entered Broderick's chest, and the senator died three days later. The shots are considered by many to be the first fired in anger over slavery issues predating the Civil War. The markers were placed by Native Sons of the Golden West in 1917. Broderick-Terry Duel Site Park, near the intersection of El Portal and Cliffside Drive, may be visited daily. (Courtesy of Gillespie collection.)

EXPLOSIVES FROM COLMA. Fuses from the California Fuse Company of Colma and blasting materials from the California Powder Works of Colma were used for rock blasting during the construction of railroad passages through the Sierra Nevada mountains in the 1860s. (Courtesy of DC/C HG, donated by Russell Brabec.)

RELIC OF THE PAST. Robert Sheldon Thornton, the first person to settle on property in what would become Daly City, arrived in 1853 and had this house constructed in 1866. In its day, the two-story building was considered a mansion, complete with an ornate marble fireplace. In 1948, it was moved from its original site to accommodate building of a portion of a highway. Shortly after this photo was taken, the relic was destroyed to allow development of an automobile rehabilitation business on the site. Previously, the historic Thornton House was used as a multiple-family rental property. This 1997 photo only hints at the elegance of what was once the residence of the Thornton family and the seat of Robert Thornton's various business enterprises in the north county. (Courtesy of Gillespie collection.)

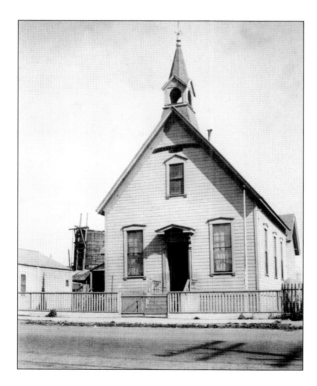

EDUCATIONAL EDIFICE. This sturdy building with the tall flag pole at its front was one of the earliest pioneer schools in Colma, built only a few years after the formation of Jefferson School District in 1866. A one-room school preceded the district ten years earlier. The building, dominating the area, was located close to a train stop in Colma. The depot and the school were so closely situated that railroad personnel chose to designate the station as School House Station on traffic schedules. The name was later given to the nearby post office and used until 1888 when Colma became the official name for the still unincorporated area of San Mateo County. Today's School Street perpetuates the name, and a late 20th-century housing and business complex on nearby Mission Street recalls the depot. (Courtesy of DC/C HG.)

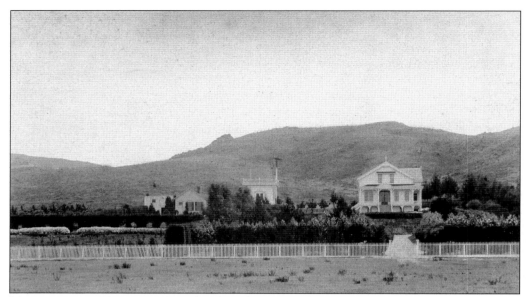

MEUSSDORFFER MANSION. Completed in the 1880s, the 22-room Victorian "country home" of the John Meussdorffer family in the Crocker Tract was spectacular. Mr. Meussdorffer had emigrated from Switzerland to seek California gold, but made the family fortune manufacturing and selling hats to 49'ers. The collapsible opera hat was his invention. Before the 1906 earthquake and fire in San Francisco, Meussdorffer owned the land now occupied by the San Francisco City Hall. (Courtesy of DC/C HG.)

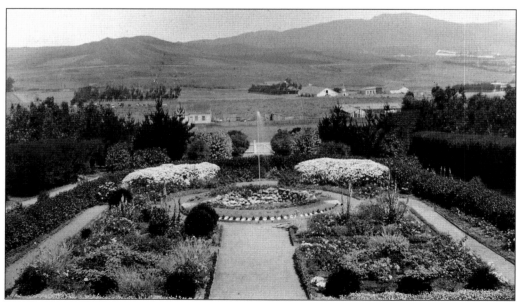

PATHWAYS AND PRIVACY. The magnificently landscaped grounds of the block-square Meussdorffer residence pre-dated Daly City by over thirty years, but remained relatively untouched by advances of the community that would surround them. The gingerbread structure that looked out upon these gardens was destroyed by fire in 1960. George Washington School now occupies the property. (Courtesy of DC/C HG collection.)

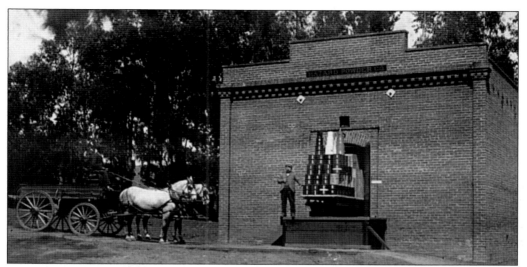

CONTROVERSIAL MAGAZINE. Hazard Powder Company's storehouse was the target of a removal petition in 1882, when its Colma neighbors complained about potentially dangerous proximity. The business was located on Wyandotte Street, with the nearest dwelling about 1,800 feet distant. The petition failed and HPC was still in business at the turn of the century. Guarding the facility is Henry Kluge. (Courtesy of DC/C HG, donated by Marie Rusert.)

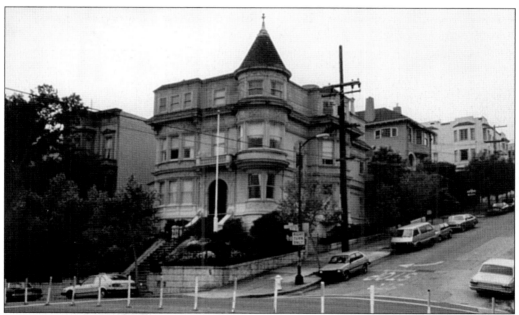

DOMESTIC ELEGANCE. John Donald Daly had this multi-storied Victorian-style home constructed at Twenty-first and Guerrero streets in San Francisco in 1885. Although still operating his highly successful San Mateo Dairy on Daly's Hill, in what was to become Daly City in 1911, Daly chose the residence for proximity to better schools for his four daughters and son. With live-in servants, the Daly family enjoyed the mansion for many years. In addition, Mr. Daly maintained a small cottage for his own use near his ranch. The 1906 San Francisco earthquake and fire did not endanger this building, and it is still occupied. (Courtesy of Gillespie collection.)

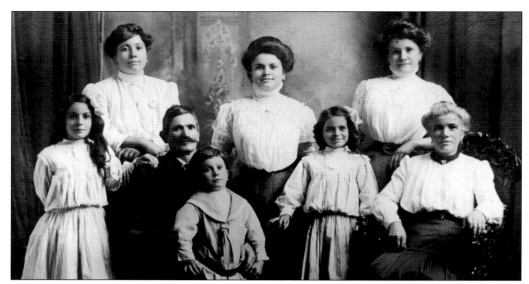

THE GIACOMO VARNI FAMILY. Giacomo Varni, his wife Rosa, and their daughter Mary, aged three, migrated from Italy to Colma in 1885. He farmed and worked for the quarry at the Top of the Hill that supplied rock to the Market Street Railway. Between 1885 and 1904, five more children were born. Shown from left to right are the following: (front row) Emma Varni, later Caserza; Giacomo Varni; Louis Varni; Lillian Varni, later Brunelli; and Rosa Varni; (back row) Mary Varni; Julia Varni Fisicaro; and Edith Varni Franzoia. (Courtesy of DC/C HG, donated by Lawrence Caserza.)

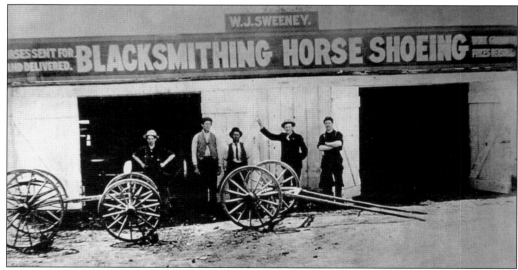

BRAWNY BLACKSMITHS. William J. Sweeney Sr.'s blacksmithing business in the Vista Grande area dates back to the 1890s at the corner of what became Westlake Avenue and Mission Street. At the same time, Sweeney's grandfather Jim Ryan operated a roadhouse next door to the shop in which William worked as a blacksmith. Early services included sending for, and delivering, horses. Sweeney became one of the first new car dealers in the area, successfully keeping pace with automotive transportation demands of local farmers and commuters for many years. (Courtesy of DC/C HG.)

14

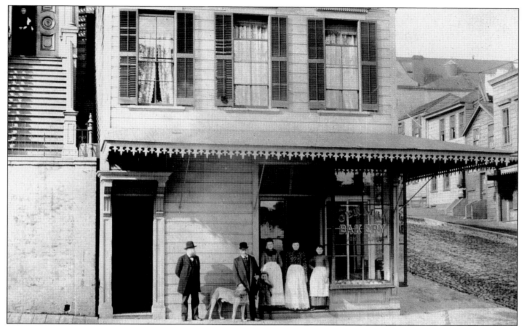

BUILDER'S BIRTHPLACE. When this 1891 photo was taken, Henry Doelger was not even a gleam in his parents' eyes. Five years later, immigrants John and Julia Doelger became parents of their second son in an apartment behind the German Bakery they owned and operated at the corner of Mason and Pacific Streets in San Francisco. They named him Henry. In 1945, he would become the entrepreneur behind the development of Westlake, one of the nation's first completely planned communities. (Courtesy of DC/C HG, donated by Doelger Estate.)

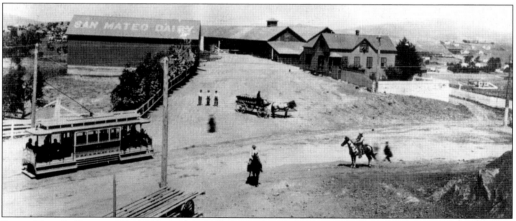

JOHN DALY'S RANCH. In 1892, Daly's Hill was a designated stop on the San Francisco–San Mateo Railroad Co. line. Shown are Daly's San Mateo Dairy ranch buildings and residence on hilltop property he acquired in 1868, adjacent to roads now identifiable as Mission Street and San Jose Avenue. Scattered San Francisco county line houses are in the background, right. To the left, cows graze near Daly's barns as an open-end streetcar rumbles past the ranch. In the center, a horse-drawn wagon, fully loaded with milk cans, starts its journey into San Francisco. The shadowy figure to the right of the pinto horse and cowboy might be Daly himself, wearing the formal business attire with white vest that had already become his trademark. (Courtesy of DC/C HG.)

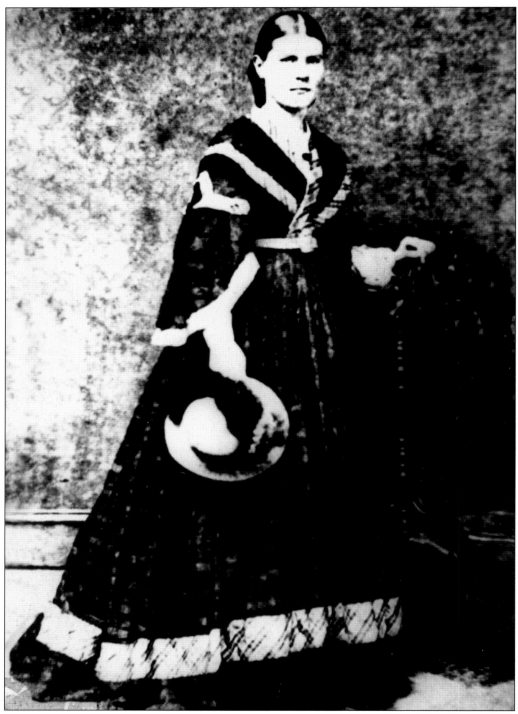

LILLIE CARRICK DALY. Married to a prosperous rancher, Mrs. John Donald Daly displays finery of the 1890s. The Dalys lived at the San Mateo Dairy near the Top of the Hill for about ten years before moving into a large San Francisco home. (Courtesy of DC/C HG.)

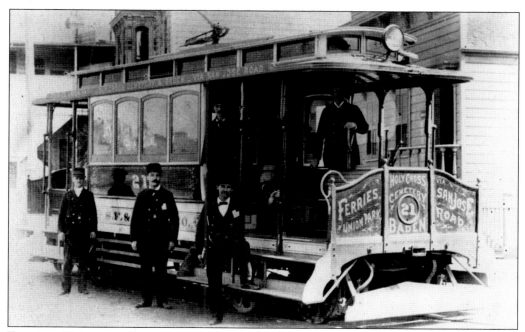

ELECTRIC ELEGANCE. Commencing in 1893, the San Francisco–San Mateo Railroad Company provided transportation to Daly City and Colma. With a good grasp on the controls, the motorman is ready to shout "All Aboard!" for the south-bound ride to Holy Cross Cemetery and the settlement of Baden via San Jose Road. (Courtesy of DC/C HG.)

VISTA GRANDE SCHOOL. An 1894 school bond issue financed this elegantly styled Mission Street building that weathered the turn of the century and continued as a North County landmark for many years. A metal escape slide outside the building provided hasty exit from the upper level in case of fire alerts. Living up to its name, the facility did indeed, offer a grand view of the surrounding homes and gentle hillsides. This view is from the east side of Mission Street, when that area was still fenced and used as grazing land for farm animals. The cluster of trees at the center are in Knowles Gulch, later Knowles Park, Vista Grande Park, and, lastly, Marchbank Park. (Courtesy of DC/C HG.)

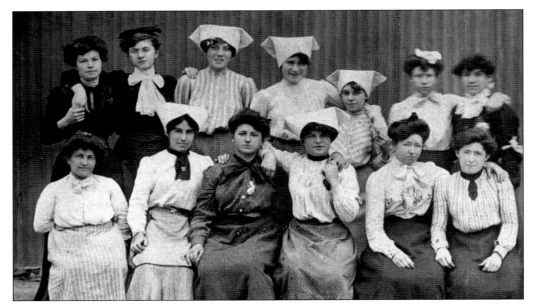

FUSE FACTORY TRAGEDY. On October 16, 1897, California Fuse Company workers found their factory demolished after sparks from an electric light exploded in the spinning room, causing the facility to burst into flames. One woman worker was killed and seven other workers were injured. Weeks later, the wood-frame building was rebuilt and work continued. Shown here in 1902 is another generation of fuse factory workers. (Courtesy of DC/C HG , donated by Irene Moresco Dalton.)

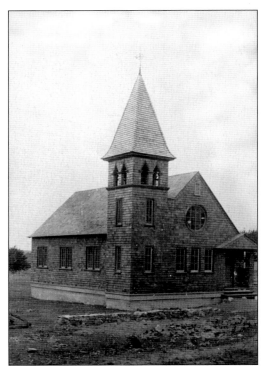

PROTESTANT CHAPEL. Organized in Colma on May 7, 1899, as the Congregational Sunday School, the Colma Protestant Sunday School incorporated in 1907 and used this building for its meetings. California Assemblyman. and Mrs. Henry Ward Brown donated the property. In 1920 the name of the facility was changed to Colma Community Center, and a library opened there in 1921. In 1933 a dining room and kitchen were added to the building. Village Nursery School was one of the last tenants of the center. The building stood as a landmark on Dunks Street until demolition in the summer of 1962 to make way for a freeway. (Courtesy of DC/C HG, donated by Mrs. Jean O'Rourk.)

COLMA HOTEL. Visiting Colma cemeteries was an important part of family activities during the early 1900s. Conveniently, streetcars stopped on Old Mission Road in front of F.G. Lambert Monument Company, next to the Colma Hotel and across the street from Holy Cross Cemetery. The tall building at left bears a sign "Cars Stop Here." Horse troughs in the street offered cooling drinks, as might the business at left with the open door. (Courtesy of DC/C HG, donated by James Farr.)

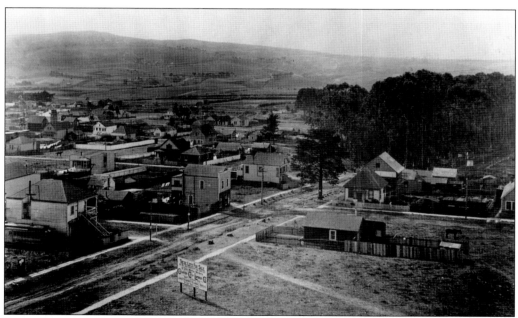

PARK AVENUE. With eucalyptus trees of Vista Grande Park at the right, tidy wood-frame homes seem almost crowded in this early 20th-century photo of the thoroughfare later to be named Parkview Avenue and split into North and South around the recreational area. On the left is the Herscowitz Store. The Beecher home is at the right foreground. The western slopes would later become Broadmoor Village, St.Francis Heights, and Westlake. (Courtesy of DC/C HG.)

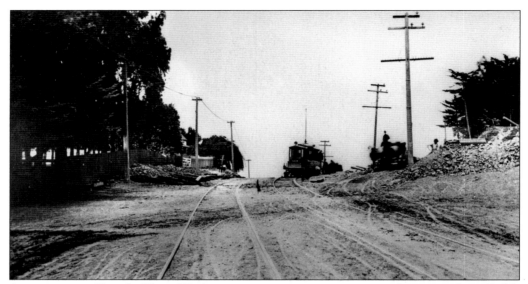

APPROACHING DALY'S HILL. Work was progressing on streetcar tracks approaching Daly's Hill in 1903. While chugging along the San Jose Avenue slope, heading south, construction equipment pauses. The trees on the right border John Daly's cattle ranch. The fenced area of the Abbey House inn/restaurant/pub and gathering place is located on the left, on the wedge between Mission Street and San Jose Avenue that would later become the site of Daly City's bank. (Courtesy of DC/C HG.)

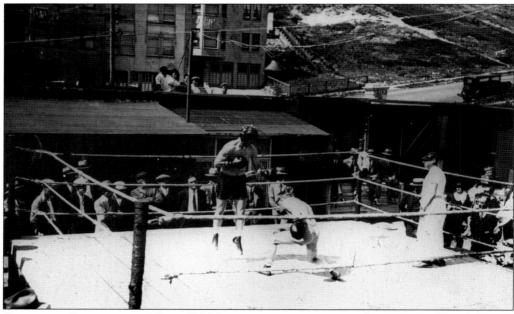

COFFROTH CONTENDERS. These 1903 boxers were among many that "put up their dukes" at Coffroth's Training Camp and arena just south of the San Francisco–San Mateo County line. Fight fans and gamblers took great interest in prizefights held in the unincorporated area of the north county, where betting on the outcome was legal. Coffroth, known as "Sunny Jim," had a knack for only scheduling bouts on sunny days. (Courtesy of DC/C HG.)

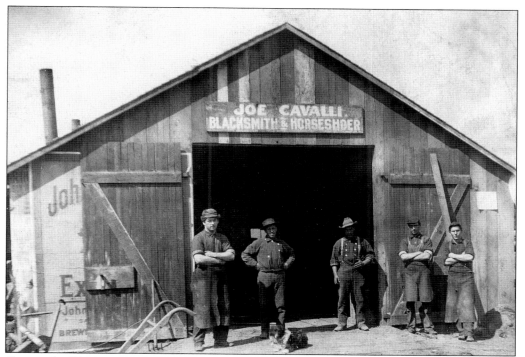

CAVALLI'S HORSESHOERS. Business was good for Joe Cavalli of Colma and his muscular blacksmiths and horseshoers in the days when horses were the main mode of transportation and vital to the working of farms and ranches. (Courtesy of DC/C HG.)

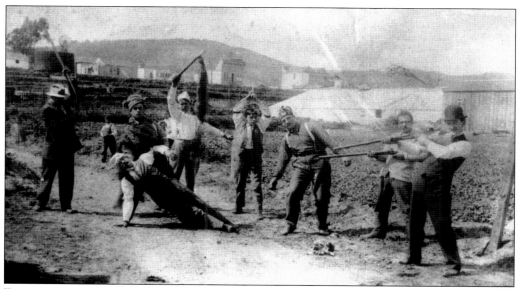

FOOLING AROUND. Even hardworking potato and onion farmers had their moments of fun, as shown in this photo, probably taken on an off-work afternoon around 1904 in Colma. (Courtesy of DC/C HG.)

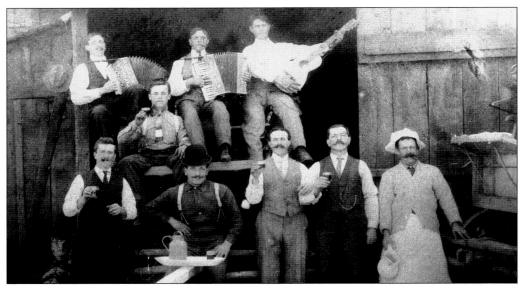

A LITTLE MUSIC, A LITTLE MIRTH. Dressed in their Sunday best, these turn-of-the-century farm workers are typical of early Colma settlers who worked hard for $6^1/_2$ days a week, and enjoyed their own good company and accomplishments on their half-day off. Sharing, sampling, and celebrating with their own supply of home-brewed wine and home-taught music were customs of the times. (Courtesy of DC/C HG.)

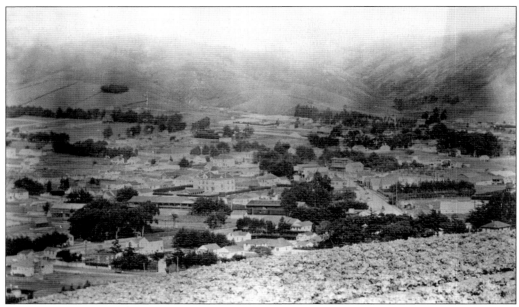

OLCESE RANCH VIEW. Cabbages grew abundantly in 1905 on the hillsides of the Olcese Ranch, where Westmoor High School is now located. Looking to the east, the old high-rise Jefferson Elementary School building may be seen in the center of the photo. With San Bruno Mountain offering benevolent shelter from coastal elements, Colma proved an excellent location for growing flowers and other field crops. Rising tall are tidy rows of trees planted to serve as protective windbreaks for agricultural endeavors. (Courtesy of DC/C HG.)

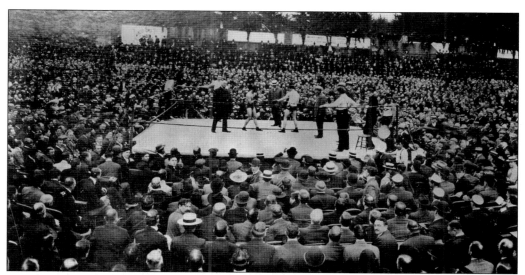

CHAMPIONSHIP IN COLMA. Boxing fans arrived by the thousands on September 9, 1905, for the match between lightweight titleholder "Battling" Nelson and the favorite, Jimmy Britt. Scheduled to last 45 rounds, the event ended with a knock-out by Nelson in the 18th. The referee was Eddie Graney. Promoter James "Sunny Jim" Coffroth had hurriedly constructed the arena at the abandoned Union Park Race Course, a former dog racing track, later to be occupied by Jefferson High School. The arena was used only for that one premier bout, although boxing continued locally for almost a decade. (Courtesy of DC/C HG.)

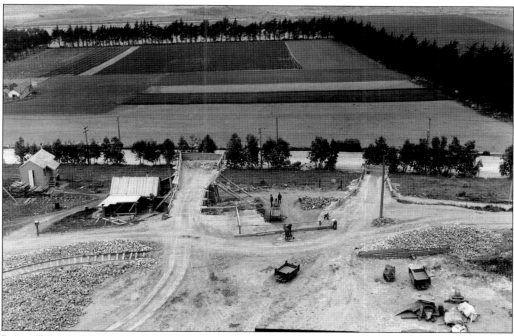

JOHN DALY'S ROCK QUARRY. In 1905, John Daly's quarry near the Top of the Hill supplied chunks of rock broken to size for the lining of Market Street Railway rail beds. This view looks west from above the quarry. (Courtesy of DC/C HG.)

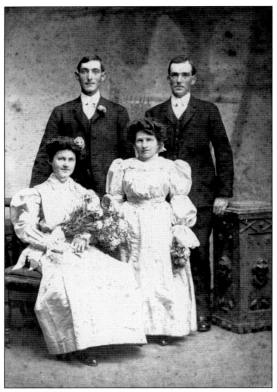

WATCHING THE BIRDIE. Posing politely for the photographer in 1905 or 1906, this well-dressed quartet chose Colma field flowers to highlight their wedding finery. Shown, from left to right, are bride Edith Cavo Silicani, groom Joe Silicani, Rose Cavo, and unidentified. The father of Edith and Rose was Augustino Cavo, an artisian in granite who founded the Colma monument business that was sold in 1921 to Valerio Fontana. (Courtesy of Valerie Barsotti Tribou and Matilda Dorland.)

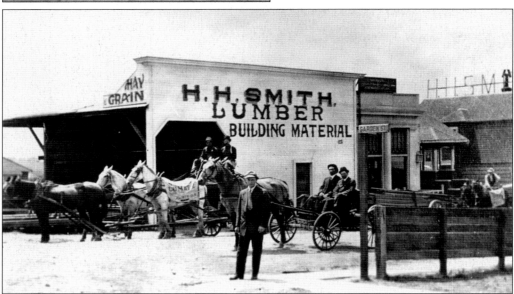

ENTERPRISING GENTLEMAN. Hugh Henry "HH" Smith recognized a need and did a thriving business hauling "shacks" out of San Francisco after the 1906 earthquake and fire. The tiny buildings became emergency homes and the nucleus of housing for residents that voted to become Daly City in 1911. Innovatively, Mr. Smith advertised his business atop a neighboring roof (at right) and on his draped white horse. (Courtesy of DC/C HG.)

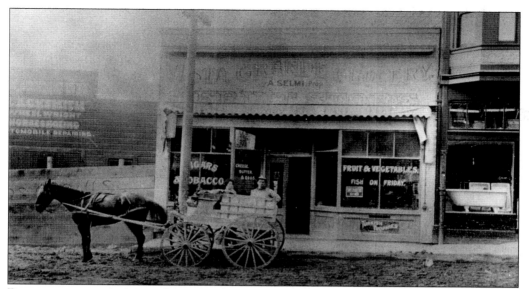

DELIVERY WITH A NEIGH. The clip-clops of horses' hooves were commonplace when this vintage photo was snapped. The couple standing with pride in front of the Vista Grande Grocery and Fruit Store, established in 1907, is believed to be A. Selmi, proprietor, and Mrs. Selmi. The store sold fruit, vegetables, cheese, butter, eggs, cigars, tobacco, and fish (on Fridays). (Courtesy of DC/C HG.)

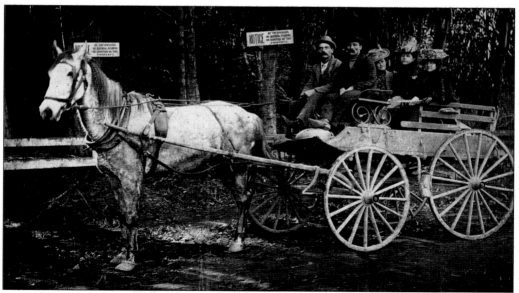

AFTERNOON OUTING. All dressed up and out for a good time are these 1907 joy riders. Signs posted on background trees suggest "NO trespassing, NO bathing, fishing, shooting." Shown, from left to right, are an unidentified driver (who probably owned the horse and rental wagon), Vincent Amoroso, Mamie Cavo Amoroso (with head on Vincent's shoulder), Mary Cavo Bandino, and Rose Cavo Barsotti. Fancy flower-trimmed hats and fur jackets were popular items of attire for ladies while handsomely trimmed mustaches were the fad for gentlemen. (Courtesy of Valerie Barsotti Tribou and Matilda Dorland.)

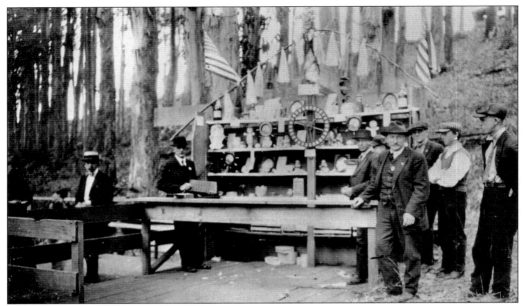

WHEEL OF FORTUNE. Inviting thrill seekers to try their luck at winning prizes by spinning the numbered wheel are these off-duty members of the Vista Grande Volunteer Fire Department, organized in 1907. Eucalyptus trees in Vista Grande Park provided shelter for various activities, including al fresco dancing on a planked wooden floor. (Courtesy of DC/C HG.)

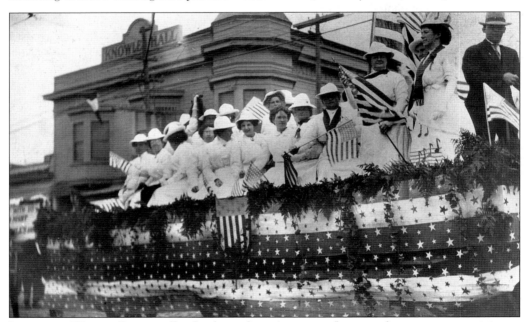

LADIES IN WHITE. Patriotically clutching their American flags are these women participants in the local Independence Day parade of 1907 as their float was pulled on Mission Street near Hillcrest Drive. Decked out in white aboard a horse-drawn wagon are members of Vista Grande area's "Companions of the Forest" auxiliary of the Independent Order of Foresters. Behind them is Knowles Hall, a landmark Top of the Hill business and office building. (Courtesy of DC/C HG.)

OFF FOR THE DAY. Adventuring along the coast on the Ocean Shore Railroad was a popular weekend activity for men and women of the Green Leaf Social Club of Colma, shown here at Green Canyon. This photo was taken while the train took on water for its steam-propelled engine. The line carried its first passengers on June 21, 1908, and continued operating until 1920. (Courtesy of DC/C HG, donated by Irene Moresco Dalton.)

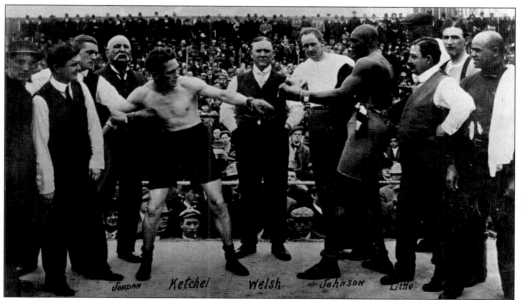

BIG TIME BOXING. World heavyweight champion Jack Johnson prepared to defend his boxing title in Colma on October 16, 1909, in a match at Coffroth's Arena against "Great White Hope" contender Stanley Ketchell. A multitude of boxing fans viewed the event, many of whom arrived by specially chartered trains. Johnson won, knocking out Ketchell in the 12th round, and retaining his title as the first African-American heavyweight boxing champion. At the time, he was considered the most controversial boxing champion in the history of the sport. (Courtesy of DC/C HG.)

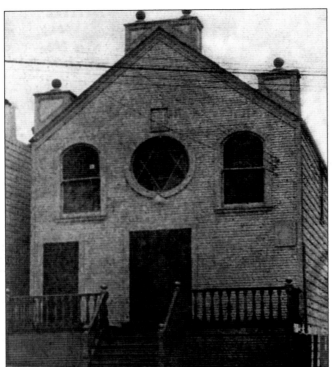

B'NAI ISRAEL SYNAGOGUE. Built in 1909, this building was the center of religious and social activities of Daly City's Jewry for many years, and was the first Jewish synagogue on the Peninsula. The father of the great violinist, Yehudi Menuhin, offered his services here as a Hebrew teacher. The building at 67 Los Banos Avenue also housed the Daughters of Israel. In 1964, the Congregation built a new Temple at 1575 Annie Street, Colma. (Courtesy of DC/C HG.)

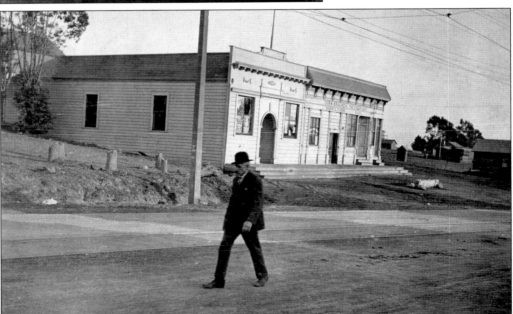

FIRST COMMUNITY BUILDING. Brackens Hall, built in 1908, was the first social hall constructed in the Vista Grande area. Located on Mission Street between Beta and Como Streets, the facility only lasted about two years. In the background are some of the emergency "shacks" hauled from San Francisco after the 1906 earthquake and fire. (Courtesy of DC/C HG, donated by Arthur J. Bodien.)

POKET'S SALOON. Today the name would probably be "Poket's Pub," with pleasant alliteration, but in 1909 a saloon was the neighborhood hangout and place to enjoy a nickel brew while chomping down a free lunch. Male patrons could enter through fancy glass-paneled doors, while ladies were provided with a discreet entrance to the right. In 1910, bartender James Poket became the manager of the first baseball team organized in the area. Proprietor of the popular business was one L. Poket, probably the gentleman at the right with the prosperous demeanor. (Courtesy of DC/C HG.)

AN "OOOPS" EVENT. The day didn't start all that well for the owner of this overturned vegetable wagon at the Top of the Hill in the 1910s. While cabbages clustered in the street, one can only wonder what happened to the horse that had been pulling the wagon, what flipped the cart, and whether the people on the far left would be having cooked cabbage for dinner that night. Pre-dawn delivery of fresh vegetables to San Francisco restaurants and markets was a daily activity of Colma ranchers. (Courtesy of DC/C HG.)

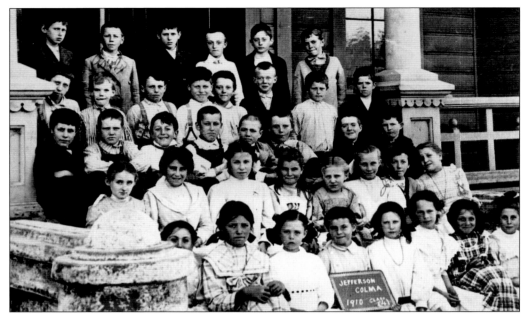

Handsome Children. Jefferson School District had been a recognized entity in Colma for almost 50 years when these attractive fourth grade students posed on the steps in front of Jefferson School in 1910. Written in chalk on a small slate is the class's identification. Organized by pioneer resident Robert Sheldon Thornton in 1856, the district name honored President Thomas Jefferson (1801–1809), whose policies Thornton highly admired. (Courtesy of DC/C HG.)

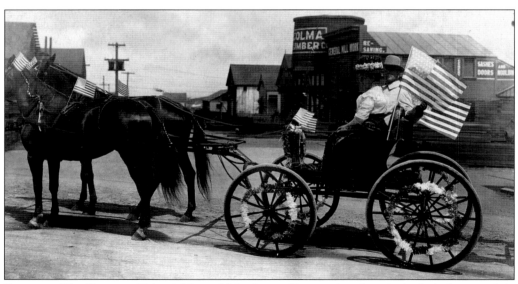

Showing His Colors. Colma's Mr. and Mrs. James Casey enjoyed a spin in their decorated rig just after he had been elected to the San Mateo County Board of Supervisors. Casey's campaign for the improvement of roads earned him the nickname, "Good Roads Casey." His concentrated efforts helped to bring state highway status to Mission Street and El Camino Real. (Courtesy of DC/C HG.)

Two

THE HOSPITABLE MOUNTAIN
1911–1940

In 1911, when settlers of several housing developments in north San Mateo County voted to incorporate as a sixth class city, dairy rancher John Daly was honored to have the new entity named for him. He was so pleased, as the story goes, that he personally presented each local lady with a flower from his dahlia garden.

After the 1906 earthquake and fire in San Francisco, Daly had allowed refugees to take shelter on his property. His kindness as a good neighbor did not go unnoticed. Of the name for Daly City, a simple indication of "aye" voters had affirmed John Daly's popularity.

Almost a decade and a half later, San Bruno Mountain saw the heavily agricultural area of unincorporated Colma emerge into the Town of Colma in 1924. The name may, or may not, be a corruption of the name of the gold mining town of Coloma in the California hills. A popular story tells of a young passenger on a train poking his head out into the natural freshness of the surrounding air and remarking, "Gee, it's cold, Ma!"

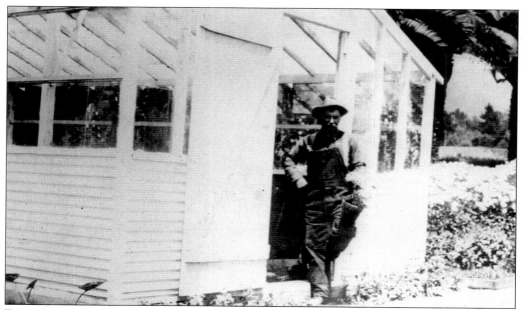

FIRST GREENHOUSE. Colma horticulturist Frank Barsotti takes a breather while holding a potted plant in front of the first greenhouse constructed on the grounds of the Italian Cemetery in this c. 1910 photograph. The facility, originally located in the San Francisco area known as Lincoln Park, opened in Colma in 1899. (Courtesy of Valerie Barsotti Tribou and Matilda Dorland.)

NAUGHT BUT JOY. Achieving incorporation by an official vote tally of 138 to 136, Daly City became reality by popular election on March 18, 1911. Four days later Daly City's articles of incorporation were filed and the entity was listed among California cities. Jubilant citizens gave themselves a "birthday" party on July 4 of that year. *The Colma Record*, in its weekly edition for March 24, 1911, noted "the stride for the betterment of our city is made . . . there is naught but joy at the result." (Courtesy of Gillespie collection.)

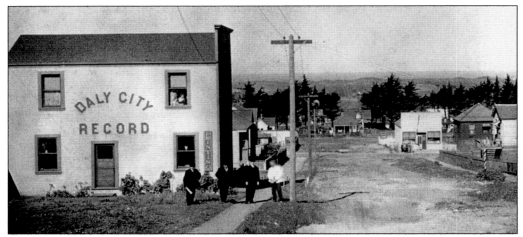

ALL THE NEWS FIT TO PRINT. The *Daly City Record*, established in 1905, was edited, published, printed, and distributed from this office on Theta Street, near Mission Street, in 1912. Open space was plentiful and streets were unpaved, but the first of Daly City's concrete sidewalks had been installed. While an unidentified woman in the window watches from the second floor, editor J.L. Brown is probably one of the men wearing their good suits. On a clear day, the Farallon Islands could be seen beyond the trees. (Courtesy of DC/C HG.)

DALY CITY'S FIRST MAYOR.
Edward Freyer, 55, a Mission
Tract resident who'd come to
California from Ohio, was elected
president of the board of trustees
for Daly City upon incorporation,
having claimed 131 votes.
Twenty-five other men also ran
for council seats. He listed his
occupation as "Superintendent,"
but some say he was out of
work at the time and thus
available to serve the new city
and its unpredictable demands.
(Courtesy of DC/C HG.)

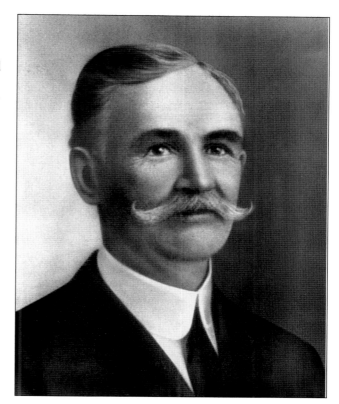

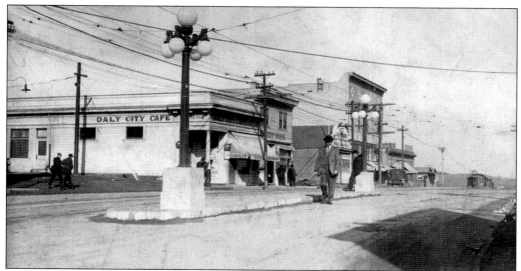

TOP OF THE HILL. Backed by the popular Daly City Café on Mission Street at Hillcrest
Avenue is the streetcar waiting station, complete with bubble lights and raised elevation.
The platform was given to the people of Daly City by John Donald Daly when the city
incorporated in 1911 and named the new entity in his honor. Until 1907, the area was
known as Daly's Hill, noting the establishment of his San Mateo Dairy ranch operations.
(Courtesy of DC/C HG, donated by Rita Perada.)

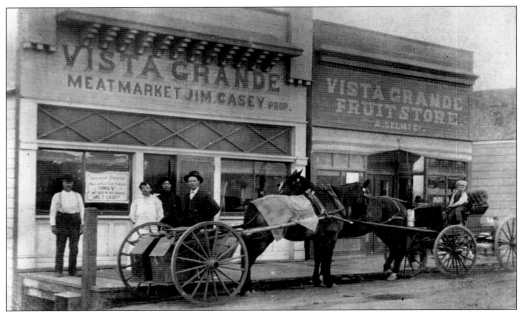

DELIVERY A LA "CART." Only government-inspected and -approved meat was sold at James Casey's Vista Grande Meat Market in 1912. The store offered free delivery of ice-packed meat conveyed in Casey's customized, horse-drawn wagon (at left) with covered drayage containers. Shown, from left to right, are Frank Smack, Matt Grady, Jack Doyle (the city's first chief of police), James Casey, and (in family rig) James Casey Jr. The Vista Grande Fruit Store behind Jim Jr. was one of several locations operated by A. Selmi Co. (Courtesy of DC/C HG.)

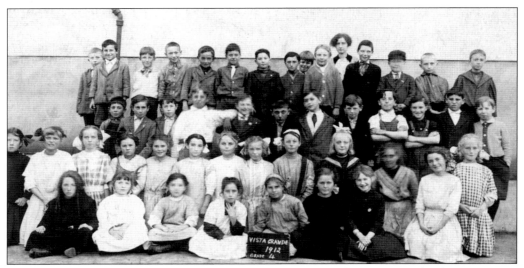

POSTAL PHOTO CARDS. For a few years, class photos taken in the Jefferson School District were printed on postal-card stock, suitable for purchasing and mailing to relatives and friends. Because of the tendency of paper to dry out and disintegrate, very few of the postcards survived in family scrapbooks or trinket boxes. This 1912 group of fourth graders and their teacher gathered on risers in front of Vista Grande School's modern (outside the walls) plumbing. Classes were suspended during harvest months to allow youngsters to help with farm labors. (Courtesy of DC/C HG.)

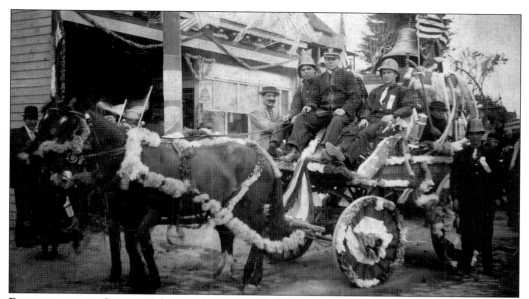

PARADE WITH A CAUSE. Volunteer firemen of Daly City took part in a July 4 parade in 1912 to promote the city's first capital improvement program. The $100,000 bond issue would finance construction of a municipal water system. Prominent on this horse-drawn float is a fire bell purchased in 1907 with funds raised by members of the Vista Grande Improvement Club Ladies' Auxiliary. Firemen and ladies followed the decorated wagon as it moved along Santa Barbara Avenue. (Courtesy of DC/C HG.)

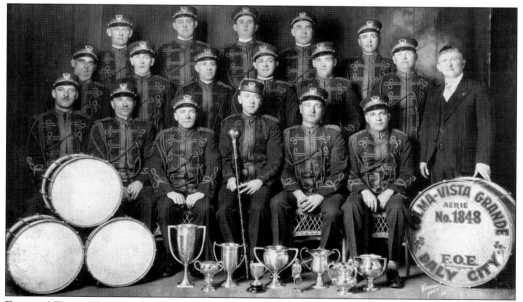

EAGLES' DRUM CORPS. Regular band practice in Colma Hall and their snazzy parade uniforms contributed to the popularity of the award-winning Fraternal Order of Eagles' drum corps. Among those shown in this 1912 photo are Gus Ford, Jim Reardon, Fred Collins, Otto Schram, Arthur Bodien, Bill Bolger, Francis Bracken, Ed Heim, and Tony Parmisano. (Courtesy of DC/C HG, donated by Arthur Bodien.)

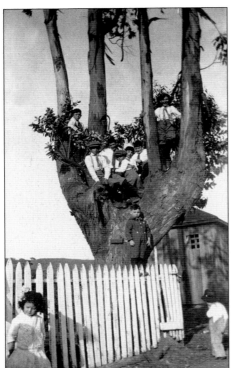

TOTS IN A TREE. Youngsters of 1913 were determined to rise to greater heights at this Colma birthday party, where tree climbing in knickers and dress-up ties was not forbidden. (Courtesy of Dorothy Hiller.)

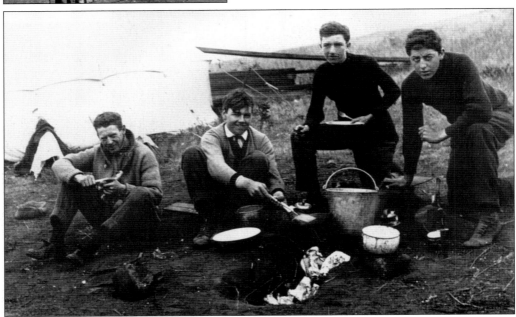

DUNE BUDDIES. Shortly before family reverses brought an end to his formal education, eighth-grader Henry Doelger (right) posed with pals from St. Ignatius High School during a 1912 campout on San Mateo County coastal dunes. His visit might have been prophetic. Thirty-three years later, his construction company would launch a massive project that would create Westlake, near the dunes of Daly City. (Courtesy of DC/C HG, donated by Doelger Estate.)

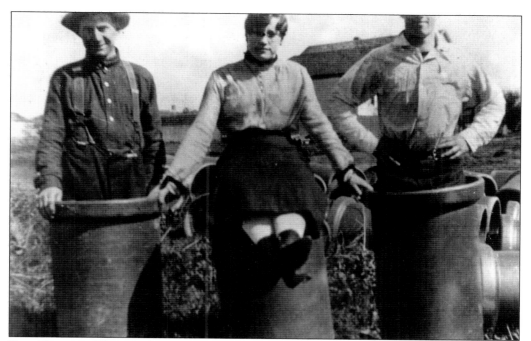

PIPE TESTING. These Daly City residents did it "their way" in 1913 when testing new water pipes to be installed throughout the city. (Courtesy of DC/C HG.)

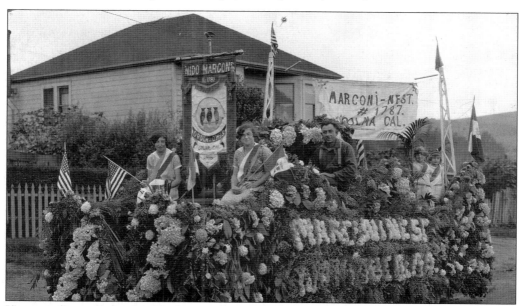

HOLIDAY FUN. Garlands of hydrangea flowers and sword ferns decorate this "Order of Owls" Fourth of July float for the North County's parade in 1912, one of the earliest community activities in newly incorporated Daly City. Girls holding American and Italian flags on the float are (left) Valerie Barsotti and Katie Abrami, while Katie's dad keeps a watchful eye. The children at right not identified. At the rear is the Balantini house on what was then called Taylor Street, now A Street in Colma. (Courtesy of Valerie Barsotti Tribou and Matilda Dorland.)

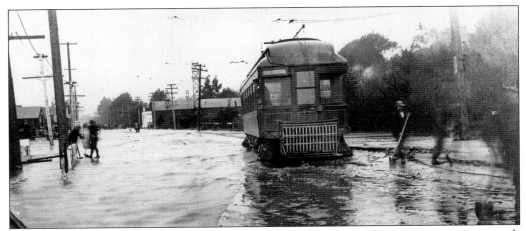

WET DAY IN COLMA. Workmen had a large task before them as heavy rains come to north San Mateo County in January of 1914. This streetcar on the suburban run from San Francisco to San Mateo was just a little bit waterlogged as it traveled past Cypress Lawn and Holy Cross Cemeteries in Colma. (Courtesy of DC/C HG.)

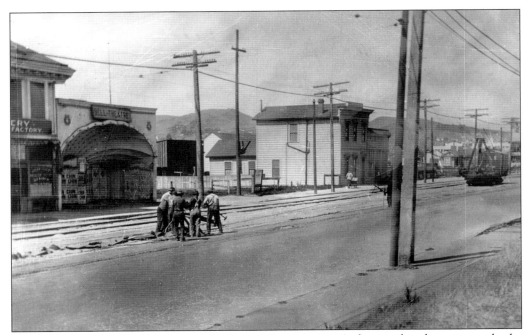

HEADING SOUTH. Heading south on Mission Street in 1916, these railroad repairmen broke the surface and inched their way along streetcar tracks near the San Francisco–San Mateo County line, between Acton Street and Templeton Avenue. San Bruno Mountain's saddle area is visible in the background. (Courtesy of DC/C HG.)

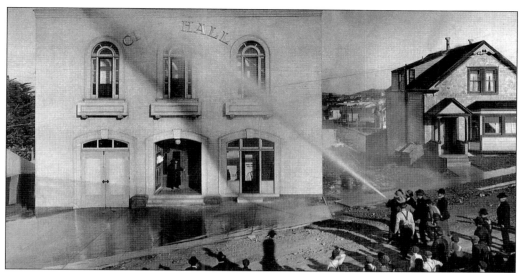

BIG DAY IN DALY CITY. Volunteer hosemen test the water pressure of Daly City's brand new domestic water system in 1915. The system was achieved through passage in 1913 of a voter-approved $100,000 bond issue. Target for testing in this photo is the Daly City City Hall, built in 1914 on Wellington Avenue near Irvington Street. Person in doorway could be then-mayor B.C. (Barney) Ross. Daly City's innovative system of laying water pipes, as well as sewer and gas pipes, in sidewalk areas, rather than dig up street pavement, was copied widely by other cities and saved Daly City many thousands of dollars. (Courtesy of DC/C HG, donated by Rita Perada.)

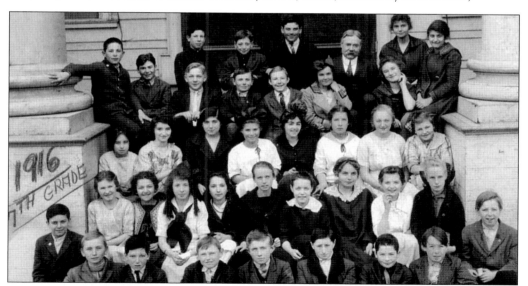

WILLIAM J. SAVAGE. With his distinctive white mustache neatly trimmed, William J. Savage, (top row, third from right) teacher and principal of Jefferson School for 20 years, was soon to end his classroom days when this 1916 photo was taken with his seventh grade class. In 1918, Mr. Savage would be named as the first Jefferson Elementary School District superintendent. He had served on the San Mateo County Board of Education since 1893. A century later, plans to name a new school in his honor were aborted. "Savage Site" property was later sold to a housing developer. (Courtesy of DC/C HG.)

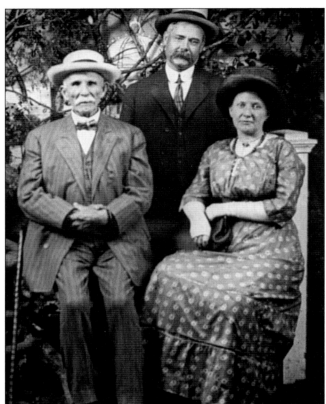

FACES OF THE PAST. In 1916, Robert Sheldon Thornton (left) was nearing the end of his remarkable 97-year life span. Alert and impressive, he posed with his daughter Mrs. Josephine Lindsay and William Savage, a mainstay of the school district founded and organized by Thornton 60 years before. Thornton's remains were sent to North Scituate, Rhode Island, for burial. (Courtesy of DC/C HG.)

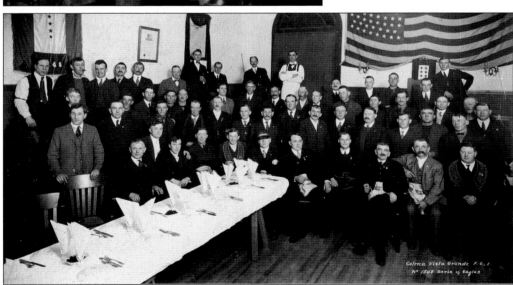

DALY CITY'S FIRST SOCIAL ORGANIZATION. Ready for a feast in this 1917 photo, the Colma–Vista Grande Aerie #1848 of the Fraternal Order of Eagles was organized in 1909, the second organization formed in the Top of the Hill district and the first devoted to fellowship. The Vista Grande Volunteer Fire Department was the first service organization. (Courtesy of DC/C HG, donated by Arthur Bodien.)

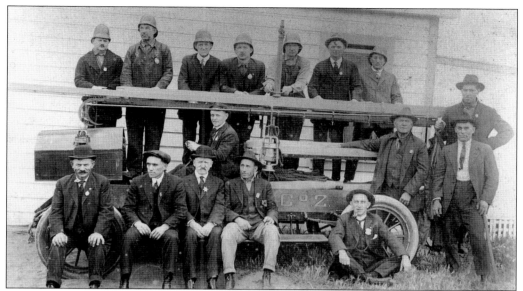

VOLUNTEERS READY TO GO. Members of the Vista Grande Volunteer Fire Department almost obscure their equipment-laden vehicle in this 1918 photo. Among those shown are, from left to right, (front row) W. Popino, H.H. Smith, H. Secore, E. Hanley, H. Rickman, C. Shoup and E. Goldkuhl Sr.; (back row) C. Edwards, assistant chief F. Hanson, F. Mikelsin, J. Nelson, E. Forsell, H. Scervin, and H. Shapero. Note the safety lanterns hanging off the truck. (Courtesy of DC/C HG.)

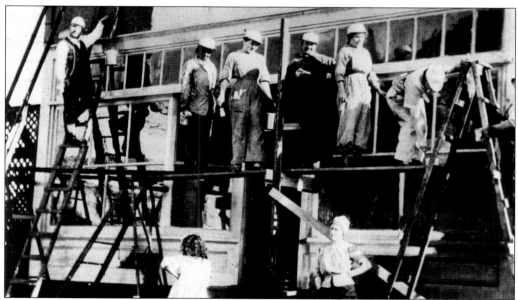

THE FAIR SEX TAKES OVER. When Daly City women found a project, there was no shortage of helpers, as this 1918 photo shows. While many of their loved ones answered the "call to arms" and performed World War I military service, these patriotic ladies donned overalls and put their touch on the local Red Cross headquarters in the 6300 block of Mission Street. (Courtesy of DC/C HG.)

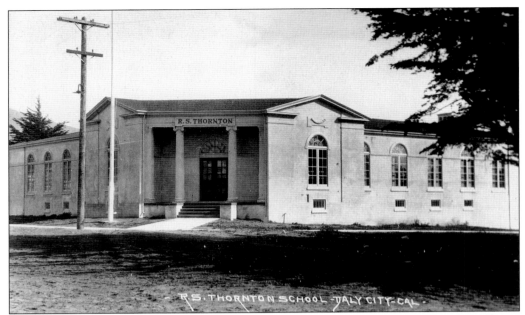

A FITTING MEMORIAL. In 1918, two years after the death of Robert S. Thornton, the Jefferson School District opened a new school and named it in honor of the old pioneer that had established the district in 1856. It was in use until 1961, first as an elementary school, then as a high school, and later as a continuation school. The building has been replaced by a new Thornton High School in the same location on Castle Street. (Courtesy of DC/C HG.)

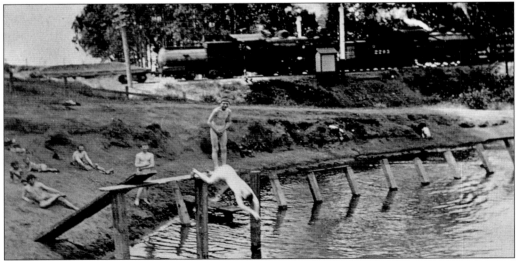

SKINNY DIPPING. It must have been an exceptional day in 1920 when these hearty youngsters enjoyed shivering, splashing, and swimming in Knowles' Pond, the site of Daly City's current Marchbank Park. In 1878, Knowles stocked the pond with fish and invited anglers to pay a fee and cast their lines, providing a popular recreational activity. Eventually purchased by John Marchbank, and given to Daly City, the 7-acre park had several previous names, including Vista Grande. As Southern Pacific Railroad trains rumbled from San Jose to San Francisco, passengers might have glimpsed more than they wished as they eyed this scene. (Courtesy of DC/C HG.)

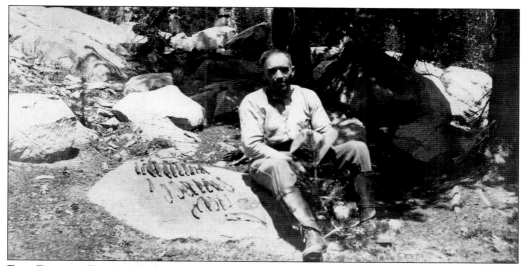

FINE DAY FOR FISHING. Daly City mayor Hugh H. Smith (1918–1936) took time out for a little fishing, as this trophy photo shows. Mr. Smith consecutively held the office of mayor longer than any other person. In later years, other mayors would be returned to office, but none served any longer than Mr. Smith. (Courtesy of DC/C HG.)

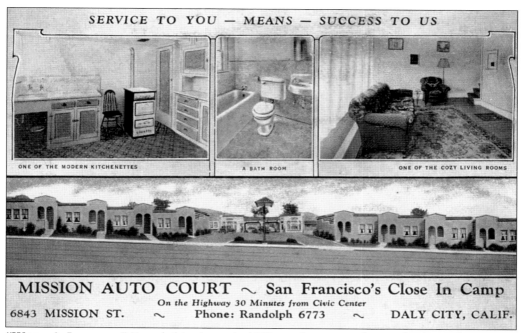

SERVICE TO YOU — MEANS — SUCCESS TO US

ONE OF THE MODERN KITCHENETTES A BATH ROOM ONE OF THE COZY LIVING ROOMS

MISSION AUTO COURT ∿ San Francisco's Close In Camp
On the Highway 30 Minutes from Civic Center
6843 MISSION ST. ∿ Phone: Randolph 6773 ∿ DALY CITY, CALIF.

"WORLD'S LARGEST." Founded in the early 1920s on four acres of prime land was the Mission Auto Court at 6843 Mission Street. The facility then offered a few frame tourist cabins and spots on which people could pitch tents. Amenities, according to an early advertisement, included a beautiful outlook with a sloping hill at the rear that was green and flower covered each spring. This advertising postcard dates from the 1930s. By 1941, the business was considered the "world's largest" with 110 cottages accommodating approximately 70,000 guests over a two-year period. (Courtesy of DC/C HG, donated by Richard and Michael Rocchetta.)

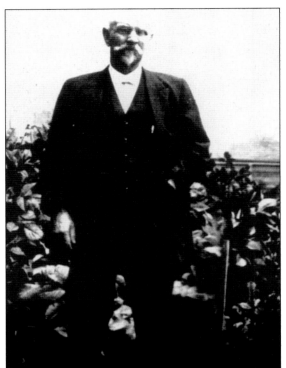

"FATHER OF DALY CITY." Wearing his trademark vest, John D. Daly proudly welcomed visitors to his violet and dahlia garden, conscientiously tended even in his later years. The garden was located in a corner of the A.L. Stockton Lumber Company, between Mission Street and San Jose Avenue. When Daly City voted to be named in Daly's honor, upon incorporation in 1911, he was so pleased that he personally presented each lady resident with a flower (women, at that time, did not have the privilege of voting). The John Daly branch of the library at the Top of the Hill on Mission Street and John Daly Boulevard (neé Alemany Boulevard) attest to his influence and popularity. He died in 1923. (Courtesy DC/C HG.)

FIRST LIBRARY BUILDING. Donated by John Daly and John Marchbank, Daly City's first library building opened April 25, 1920, at 6351 Mission Street at the Top of the Hill. The one-room facility contained approximately 500 volumes. In the background is the Daly City rock quarry. This building became the "Happy Children's Room" when an enlarged library opened in 1938. (Courtesy of DC/C HG.)

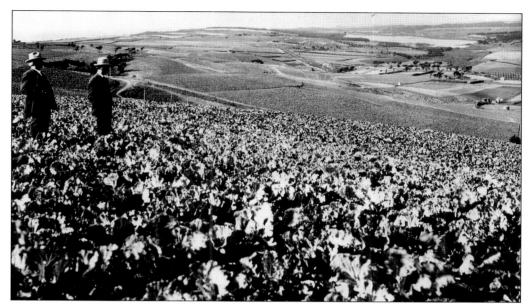

MEN OF VISION. Mid fields of cabbages, these two men were representative of pioneers that established Daly City and Colma. Shown are John Donald Daly (at left) and James Casey as they might have taken an afternoon around 1922 to envision the future of the area. Casey became known as "Good Roads Casey" for his determination as a San Mateo County supervisor to bring improved streets and highways to the north county. Daly had long been associated with the development of the area. Across ravines may be seen the trestles of the Ocean Shore Railroad. (Courtesy of DC/C HG.)

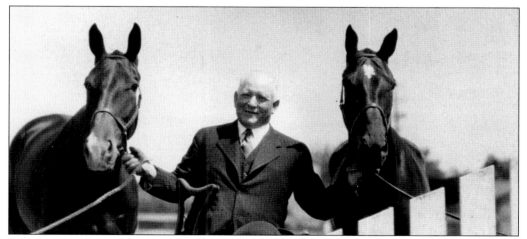

ONE-LEGGED JOHN MARCHBANK. Posing in 1922 with two of his large string of thoroughbred race horses from Heather Farms (of Contra Costa County), John W. (Jack) Marchbank's business enterprises brought success and fame. At various times, Marchbank was associated with development of the Daly City Theatre, *Daly City Record*, Tanforan Race Track, the Daly City Bank, and numerous "silent partnerships." He was often recalled as a friend to the city's needy during the Great Depression years. His casinos hired local employees, but gaming in them was forbidden to locals. He maintained a fleet of limousines in which to transport "sports" from downtown San Francisco to his establishments of chance. (Courtesy of DC/C HG.)

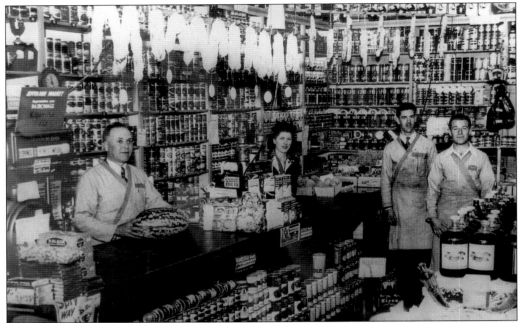

WELL STOCKED. Opened in 1923, Casentini's Jefferson Market on Mission Street in Colma was the supermarket of its day, with salami sticks hanging, tins of olive oil stacked high, an abundant supply of canned goods, and a pleasant staff to serve customers. The proprietor, happily showing a watermelon at the counter, first came from Italy in 1897. Shown are, from left to right, Guido Casentini, Angelina Casentini, Dan Casentini, and Lawrence Bottai. (Courtesy of DC/C HG.)

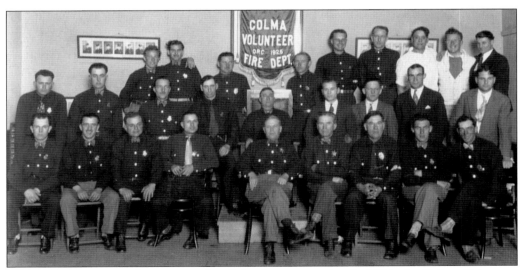

COLMA FIREFIGHTERS. Just a year after Colma's incorporation in 1924, the Colma Volunteer Fire Department organized, as the banner in this undated photo attests. (Courtesy of DC/C HG, donated by Loretta Lagomarsino.)

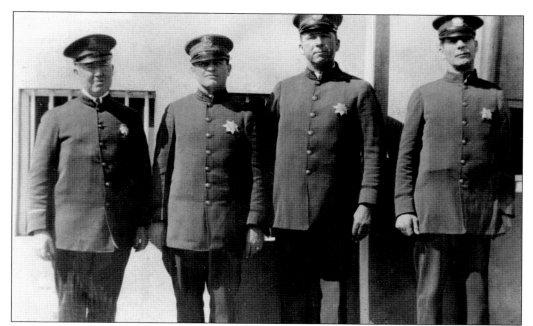

DALY CITY'S FIRST POLICE DEPARTMENT. Police Chief John T. "Jack" Doyle, shown here with his entire 1924 police force, became the city's law enforcer when Daly City incorporated in 1911. From then until 1922, he was "Marshal" Doyle, working under the city judge. With the chief are, from left to right, Officer Otto Schram, Officer George Hopman, and Officer Arthur "Barney" Hilton, who would become chief for a short while in 1938–1939. Doyle died at age 46, the victim of a hit-and-run driver. (Courtesy of DC/C HG.)

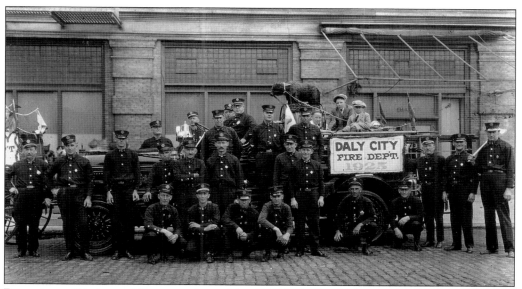

READY AND WAITING. These members of the 1925 Daly City Volunteer Fire Department must have been demonstrating that life was, indeed, "bearable" as they waited to participate in yet another civic-pride parade. The background is unidentified, as is the event, but the young boys atop the fire truck, and the bear, are ready to go. (Courtesy of DC/C HG.)

47

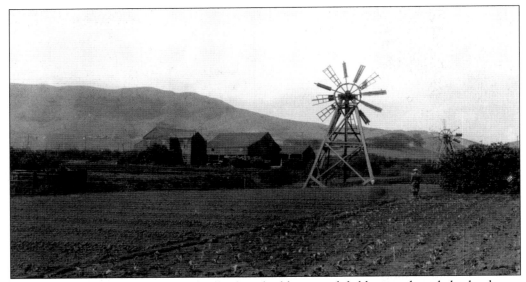

BEFORE THE COW PALACE. Windmills, farm buildings, and field crops dotted the landscape when this September 1928 photo was taken in Visitacion Valley, formerly part of the Visitacion Rancho, later Bayshore City, annexed to Daly City in 1963. Plans had started in 1915 for what would become a permanent state-operated agricultural and livestock exposition facility. On this site in 1935, ground was broken for construction of what was to become known as the Cow Palace. The Western Classic Holstein Show on April 20, 1941, officially opened the building. (Courtesy of DC/C HG, donated by Ted Wurm.)

LOOKING TOWARD THE EAST. The tall bell tower of St. Anne's Roman Catholic Church commands the scene in this 1929 photo of Washington Street. Dunks Street winds off to the right. Pioneer resident Peter Dunks donated the property on which the church was built and had it named in honor of his daughter. The church was later renamed Holy Angels. The residence of pioneer teacher Margaret Pauline Brown was located behind the white picket fence at the left. (Courtesy of DC/C HG, donated by Lou Craviotto.)

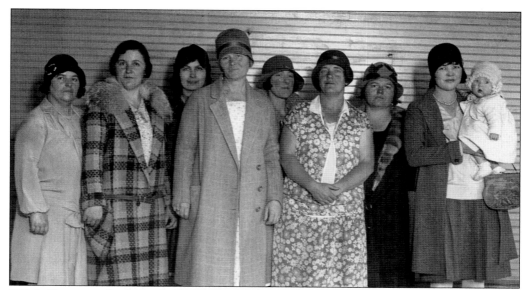

P.T.A. PIONEERS. Ladies with 1929 look-alike hats helped establish Parent Teacher Association activities at General Pershing Elementary School, 631 Hanover Street, in the Crocker home development tract of Daly City. Shown, from left to right, are Mmes. Watson, Hughes, Douglas, Watt, McNair, Fletcher, Clifton, and Colb (with baby Colb). In February of 1929, Mrs. Lillian Fletcher was elected to serve as president of the 58 charter members. Of the volunteers, the *Daly City Record* wrote, "The new officers are well-known women who have done everything to make Daly City just a little better place to live in, and the schools a little brighter to study in." (Courtesy of Gillespie collection.)

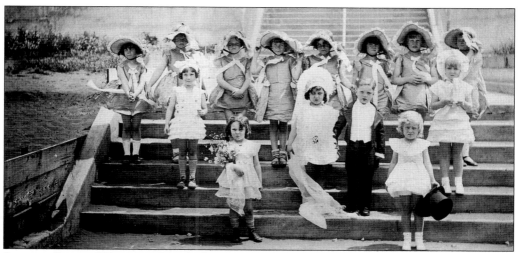

SCHOOL SHOW. What was described as "a musical extravaganza" by the *San Francisco News* was presented in June of 1929 by General Pershing School P.T.A. Lined up on the east steps of the school, "Wedding of the Painted Doll" featured students Catherine Douglas and Robert Pursley as the bride and groom. Among the cast members shown are Helen Campbell, Charlotte Hughes, Catherine and Robert, Frances McDonald, May Erwin, Hazel Anderson, Ruth Marmon, Geraldine Simonsen, Margaret Nettle, Helen Larson, and Dorothy McKeon. (Courtesy of Gillespie collection.)

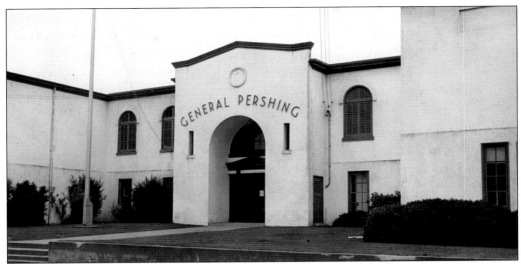

NAMED FOR A HERO. General Pershing Elementary School's first building, constructed in 1917, was named to honor one of America's World War I heroes. This 1930s stucco building, at 631 Hanover Street, replaced the original wood-frame structure. Yet another GPES was built in 1960. (Courtesy of DC/C HG.)

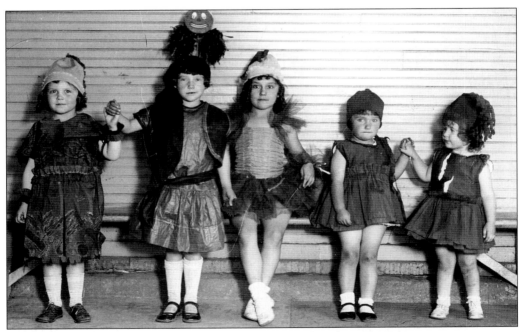

HALLOWEEN FUN. Even tots with dirty knees posed in their home-sewn crepe-paper costumes and hats to herald General Pershing School's first annual Halloween children's party and fund-raising festival in 1929. Sponsored by the school P.T.A., the event continued a busy year for charter members. Projects included assisting the school nurse with all-student dental clinics, providing food baskets for needy families, sponsoring student entertainment at the county relief home, participation at the Daly City Well Baby Clinic and Health Center, and distribution of free student lunches. (Courtesy of Gillespie collection.)

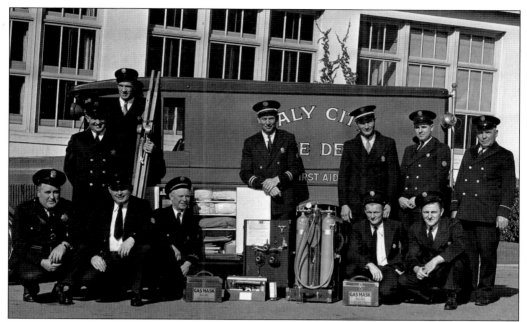

FIRST AID TRUCK. Members of Daly City's well-trained 1930s First Aid Unit of the fire department show off some of their life-saving equipment, including standing tanks of oxygen, in front of Jefferson Union High School. The tank at the left bears chalked instruction "Use This One First." At the far left is Police Officer Arthur Dalton. (Courtesy of DC/C HG, donated by Irene Moresco Dalton.)

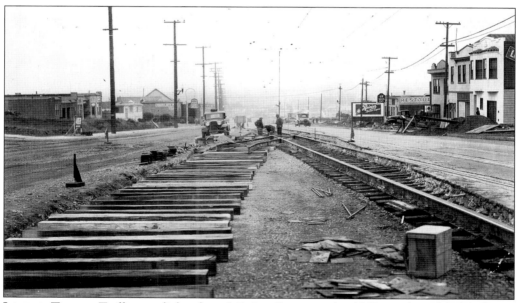

LAYING TRACK. Traffic was light along Mission Street in the 1930s as these Market Street Railway workers put down track just to the north of Mission Auto Court, on the east side of the street, and Tex's Restaurant, on the west. To the south, shrouded in fog, is Jefferson Union High School. (Courtesy of DC/C HG.)

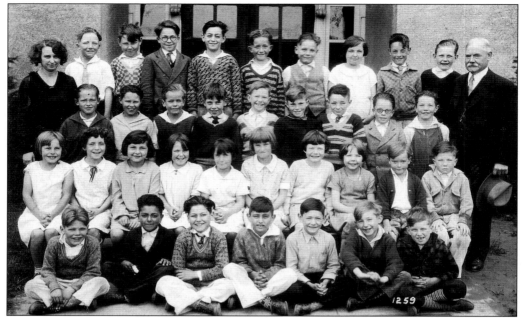

CROCKER SCHOOL STUDENTS. Bill Savage's career as an educator ended with his death in 1931. Teacher Margaret Syme Clark (top row, left) and Jefferson School District Superintendent Savage (top row, right) are shown with Crocker School youngsters. This class was among the last of the area to have its photo taken with Mr. Savage. His career as an educator had been launched in 1885. He is buried in Half Moon Bay, on the San Mateo County coast. (Courtesy of DC/C HG, donated by Walter Cavagnaro.)

SONS AND DAUGHTERS ON PARADE. Daly City and Colma teams from El Carmelo Parlor #181 of the Native Sons and Native Daughters of the Golden West strutted their stuff in the 1931 Admission Day parade in Los Angeles. A decorated Packard car, driven by drill team coach Fred Collins, displayed the Parlor banner. California governor James Rolph was among the reviewers. At the Coliseum an announcer proclaimed the local contingent to be "the snappiest and best looking team that had entered all day." (Courtesy of DC/C HG, donated by Irene Moresco Dalton.)

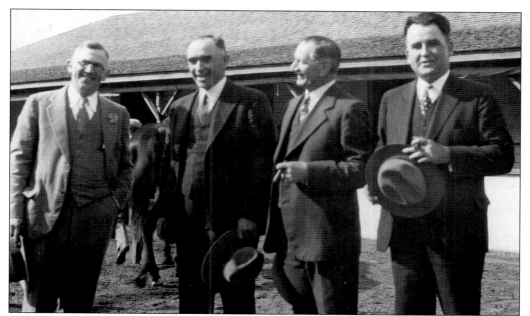

WINNERS ALL. Almost certainly not on duty, this quartet of Daly City political leaders appears to be playing the ponies in this 1931 photograph at Tanforan Race Track in San Bruno. The facility was then owned by Daly City entrepreneur John W. Marchbank. Shown, from left to right, are Henry J. Sundermann, Mayor Hugh H. Smith (1918–1936), Julius Twesten, and Arthur J. Dalton. (Courtesy of DC/C HG, donated by Irene Moresco Dalton.)

THORNTON BEACH FUN. In 1933, as the Great Depression continued, recreation was often a matter of clever inventiveness. The shanty in the back was constructed by Angelo Moresco, utilizing lumber, tar paper, and so forth washed ashore at Thornton Beach, on the Daly City coast. Never locked, the little building became a hub for good times by family, friends, and passers-by. The H-shaped frame next to shack held a long-roped swing for thrilling rides over the beach sand. An unexpected fire brought the place to an unhappy end. (Courtesy of DC/C HG, donated by Verna Moresco Calderon.)

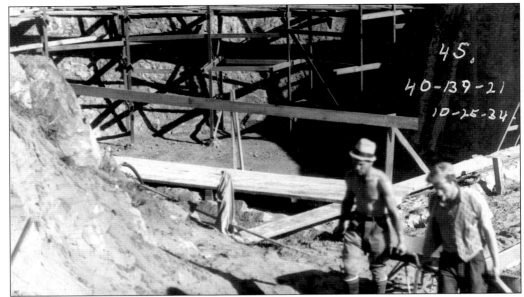

RESERVOIR #3. The third of three one-million gallon covered concrete reservoirs was on the way to completion in October of 1934, just south of Thiers Street, east of Hillside Boulevard. Daly City's water, tested monthly, showed almost 100 percent purity. For many years, residents of surrounding areas would take Daly City water to their homes. (Courtesy of DC/C HG.)

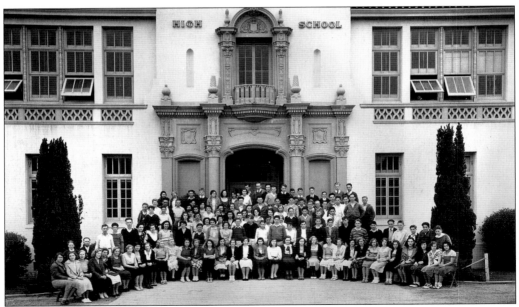

ORIGINAL JEFFERSON. The classic façade of this Mission Street building was instantly admired upon its completion in 1925. To this day, the little balcony over the main entrance is remembered with fondness. In front of the building is the Jefferson Union High School class of 1935. Bus service then was provided for Brisbane and coastside students. The Federal Emergency Administration of Public Works helped finance construction of Jeff's pool and gymnasium, dedicated in 1938. (Courtesy of DC/C HG, donated by Marilyn Olcese.)

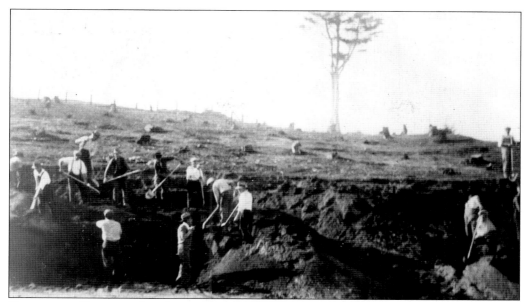

DEPRESSION DIGGERS. Local men kept pace with the rest of the country during the Great Depression as they seized opportunities to earn a few dollars in any way offered. Shown clearing ground in 1935 on Wellington Avenue are Works Progress Administration (WPA) workers. The program sought to increase purchasing power of persons on relief by employing them on useful projects. (Courtesy of DC/C HG.)

PATCHWORK FARMS. Neatly outlined by wind-breaking trees, tidy farms dotted the landscape west of Daly City in this 1936 photo. Providing access to the coast from Junipero Serra Boulevard was Alemany Boulevard, named to honor the first Roman Catholic archbishop of San Francisco. The area, then still designated as unincorporated San Mateo County, had not yet been developed into Westlake housing units and annexed to Daly City. (Courtesy of Gillespie collection.)

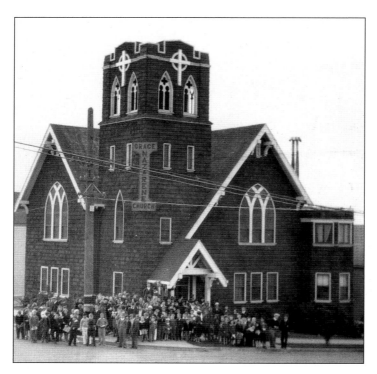

GRACE NAZARENE CHURCH. Worshipers of various ages lined up for this December, 13, 1936 photo in front of Grace Nazarene Church at 101 Vista Grande Avenue. Erected in 1921 by the Methodist Episcopal Church Extension Society, this traditional church building first housed Vista Grande Avenue Christian Church. Later it became home for Grace Nazarene Church. In March of 1989 it was dedicated for the use of the Greater Calvary Hill Missionary Baptist Church. (Courtesy of DC/C HG.)

DALY CITY'S FINEST. Officers of the Daly City Police Department have always been known for their courtesy and efficiency. Shown in this 1936 photo are, from left to right, Sgt. Roland Petrocchi, chief of police from 1951 to 1974; Chief James Reardon, 1936–1938 and 1939–1942; and Sgt. Barney Hilton, chief from 1938 to 1939. Chief Petrocchi's 23-year term of office set a record for the department. Reardon was the second and fourth chief, Hilton was the third, and Petrocchi was the seventh. (Courtesy of DC/C HG, donated by Irene Moresco Dalton.)

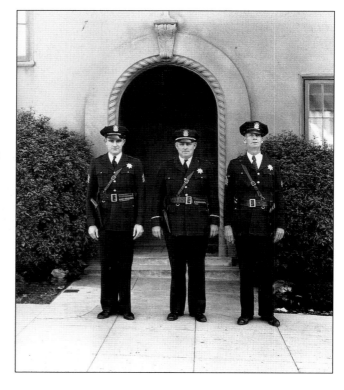

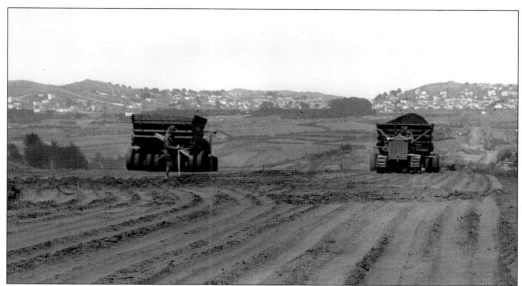

BUILDING ALEMANY. Small family farms outlined by hedges were still in operation when this 1937 documentation of the development of Alemany Boulevard was taken. The widened thoroughfare would be renamed in 1973 to honor John Daly. After World War II, land west of Junipero Serra would be developed into residential housing and businesses. (Courtesy of Doelger Estate.)

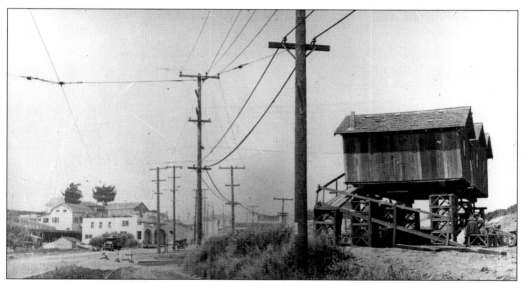

MINERVA'S FORT. When her unique home on stilts was destroyed by fire in 1937, the life of Mother Minerva, one of Colma's most illustrious residents, was snuffed also. She was 104. The widow of Civil War Navy Captain Louis W. Hartman, Minerva had been a Civil War nurse (1861). She later served with General George Custer during Indian campaigning (1876), in the Spanish-American War (1898), and in the Philippine Insurrection (1899). Minerva may be seen at the far right at the base of the 42-degree-sloped access to her residence. The structure near F Street was lifted out of the way during widening of El Camino Real on orders of California governor James Rolph. Mrs. Hartman was given a military funeral at Olivet Memorial Park in Colma. (Courtesy of DC/C HG.)

LIBRARY RENEWED. In 1938, completion of a new Daly City Public Library building at the Top of The Hill on Mission Street solved some of the needs of a growing community. The one-room library building of 1920 had been placed to the rear of this modern facility to house children's literature. (Courtesy of DC/C HG.)

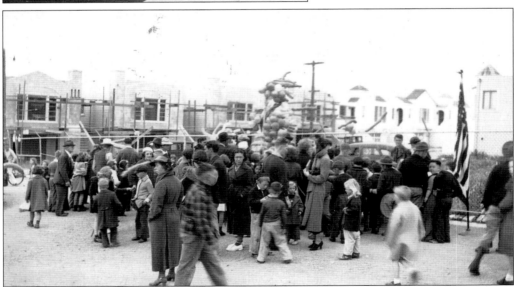

CROCKER PLAYGROUND. Residents of the Crocker tract flocked to balloon decorated festivities at Brunswick and Acton Streets in 1938 when construction of "Acton Park" was announced. Proposed for the property was a children's playground with swings, ladders, merry-go-round, and slides installed over tanbark. A recreation center, horseshoe pits, and paddle tennis court were also planned. New homes nearing completion on Brunswick Street may be seen in the background. Area cleared for the park extended 100 feet along Brunswick towards Templeton Avenue. In 1941, the name of the facility would be changed to "Lincoln Park." (Courtesy of DC/C HG.)

WARSHAWSKI'S WINDOW.
Stuffed dolls, clothing, pen
wipers, pin cushions, dish
towels, pot holders, baskets,
aprons, and cloth books
were among scrap-material
items created during the
Great Depression by locals.
A sampling of articles was
displayed in March of 1938
in the window of Mr. Henry
Warshawski's dry goods store at
6340 Mission Street. The Daly
City Recreation Department
provided volunteer instructors.
Some participants called
themselves the "Sew & Sew
Club." Co-sponsorship was by
the national WPA. (Courtesy
of Gillespie collection.)

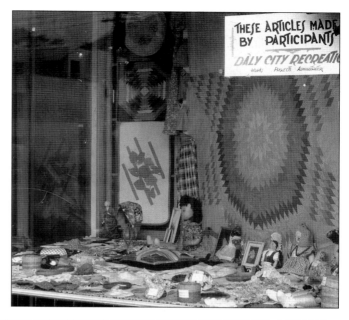

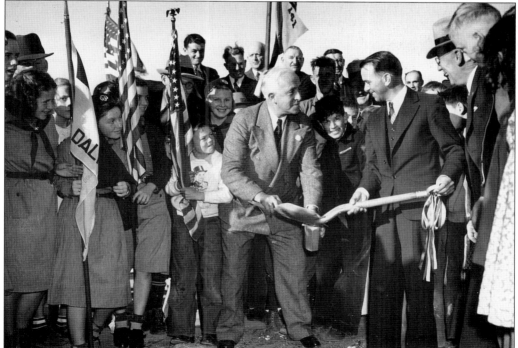

GROUND BREAKING. Daly City mayor Paul G. Selmi (1936–1940) used a ceremonial shovel to break ground on November 5, 1938, for a new city hall to be constructed at 75 Wellington Avenue. On the same site, the "old" city hall had been in use since 1914. Amenities of the modern two-story reinforced concrete building would include a fireproof three-cell jail. Interested spectators at the groundbreaking included 8th District U.S. Congressman John J. McGrath. The new city hall was to open in 1939. (Courtesy of DC/C HG, donated by Jean O'Rourk.)

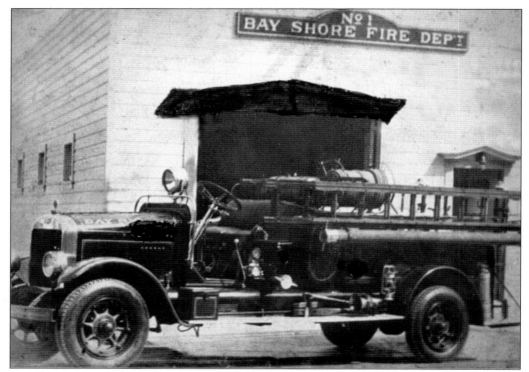

BAY SHORE FIRE ENGINE. This hose and ladder truck was a mainstay of fire-fighting equipment used in the early 1930s by the Bay Shore Fire Department, shown here fronting the area's No. 1 firehouse. The district of Bay Shore (two words) predated Bayshore City, which incorporated in 1932 to make dog racing legal within its limits, and bring financial gains to the area. Bayshore City disincorporated in 1939 and annexed to Daly City in 1963. (Courtesy of DC/C HG.)

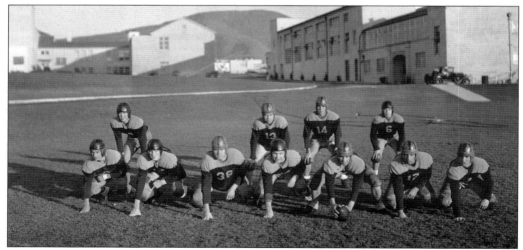

INDIANS ON THE WARPATH. Jefferson High School's football team is raring to go in this 1939 photo. The third athlete from the left is Joe Becker, and the large building to the right is the new gymnasium with swimming pool. San Bruno Mountain looms in the background. (Courtesy of DC/C HG, donated by Mary Lou Becker Sharp.)

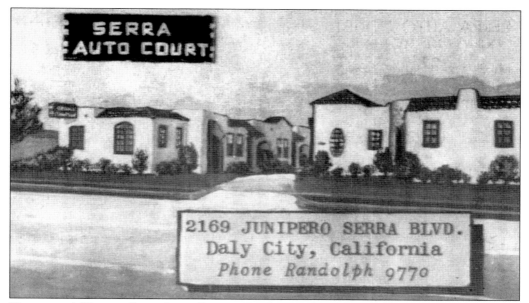

TRAVELERS' HAVEN. Serra Auto Court, one of six such modern facilities listed in the 1939 Daly City Directory, was on property that eventually became the site of the Junipero Serra Office Building, opened in 1989. In anticipation of San Francisco's 1939–1940 Golden Gate International Exposition, motor hotels, or motels (formerly called auto camps or auto courts), were developed to house fairgoers on their way to the Treasure Island spectacle. (Courtesy DC/C HG, donated by John Martin and Stan Gustavson.)

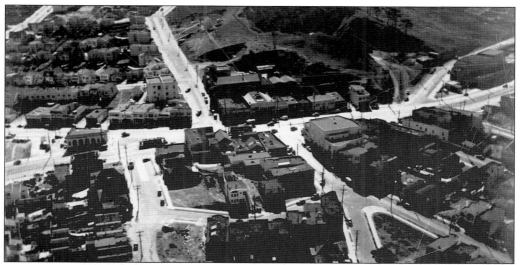

DALY CITY'S QUARRY. The rock to be used in building of streetcar and railroad beds was broken from this local site, near Hillside Boulevard's intersection with Mission Street, as seen in this photograph, probably taken in the late 1930s. Across from the quarry was Smith's Lumber Yard. The 1939 city hall may be seen on Wellington Avenue, across from Our Lady of Perpetual Help Roman Catholic Church. On the wedge between Mission Street and San Jose Avenue is the Bank of America building. The white building at Hillcrest Avenue and Mission is the Crocker Masonic Temple. (Courtesy of DC/C HG.)

GREAT DAY AT THE G.G.I.E. Daly City was honored on October 22, 1939, with its own day at the Golden Gate International Exposition on Treasure Island in San Francisco Bay. Wearing gold silk ribbons with blue ink proclaiming "Daly City at The Fair," local organizers gathered on the steps of the Mission Trails building at the exposition. Shown, from left to right, are Edmund Cavagnaro, Julius Twesten, John Fahey, and Henry Sundermann, all Daly City councilmen; Judge Wade H. Clay; Fire Chief A.P. Chesney; Herbert G. King, chairman for the Daly City fete, with notes in hand; G.G.I.E. director Art Smith; J.C. Berendsen, G.G.I.E. commissioner; Paul G. Selmi, mayor of Daly City, in light suit and holding white hat; and Julius Castelan, city engineer. Daly City boy scouts provided escort service. Ribbons sold for 10¢, and admission to the fair was 40¢. (Courtesy of DC/C HG collection)

DALY CITY DAHLIAS AT G.G.I.E. The extensive gardens of John and Irene Meussdorffer in the Crocker tract yielded these showy prize-winning specimens of horticultural expertise for competition at the Golden Gate International Exposition on Treasure Island in 1939. The dahlia has often been suggested as the "official" flower for Daly City. (Courtesy of DC/C HG, photo by G.G.I.E. Publicity Department.)

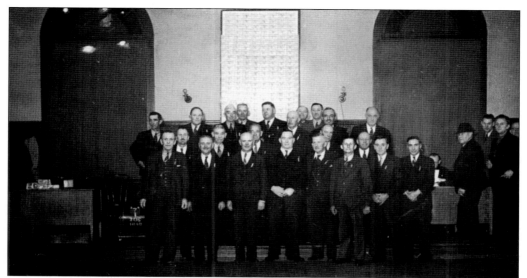

EAGLES' IN THEIR AERIE. Members of Colma Vista Grande Aerie No. 1848 of the Fraternal Order of Eagles gathered in their lodge hall in 1940 to celebrate with Arthur J. Bodien, Worthy Past President (front row, fifth from left). His unique collection of 339 monthly lodge receipts, received during his 33 years of Eagle membership, is mounted on the rectangular board on the wall behind the group. Bodien was superintendent of the Daly City Water Department at the time. (Courtesy of DC/C HG, donated by Arthur J. Bodien.)

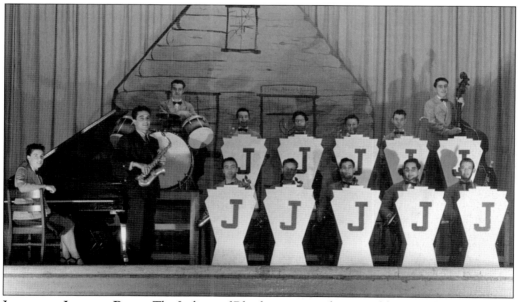

JEFFERSON INDIANS BAND. The Indians of Rhythm presented memorable music for a California Schools Week program at the Jefferson Union High School auditorium. Shown, from left to right, are (front row) Ruth Morris, director Dante P. Lembi, Lawrence Lemos, Don Thomason, Jack Parker, Angelo Ditti, and Eugene McLean; (back row) Bill Kelly, Willard Mitchell, Leonard David, Tom Beeson, Bill Gfroerer, and Roy DeVincenzi. (Courtesy of DC/C HG, donated by Bill and Trudie Gfroerer.)

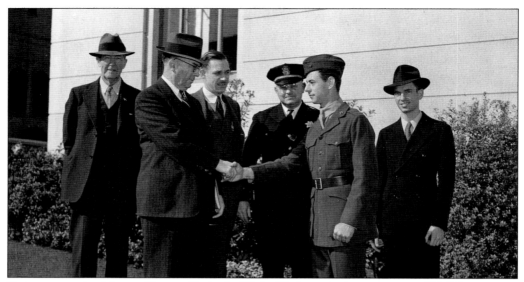

FAREWELL FROM MAYOR FAHEY. Typical of Daly City's patriotic young men, Bill Gfroerer, was wished good luck by Mayor John J. Fahey in November of 1940 when Bill was called to serve in the U.S. Marine Corps. Also shown in front of the Daly City City Hall, from left to right, are Fire Chief Andrew Chesney, member of the Disaster Preparedness Committee; Dale Hovey, *Daly City Record* photographer and reserve aerial photographer for the U.S. Army Air Corps' 88th Observation Squadron; Police Chief James G. Reardon; and Albert Boynton, publisher of the *Daly City Record* and chairman of the San Mateo County Publishers Association's committee for national defense. Bill had been an employee of the *Record*. (Courtesy of DC/C HG, donated by Bill and Trudie Gfroerer.)

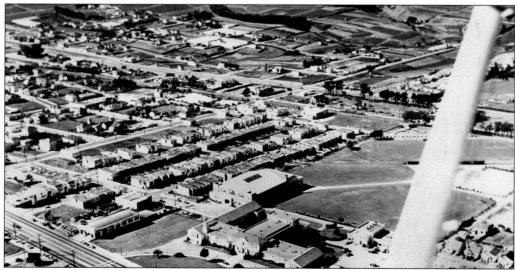

CAMPUS FROM THE AIR. In 1940, Daly City's only high school was Jefferson Union on Mission Street. The sprawling campus featured a Mission-style building accessed via a curving driveway, a new gymnasium with swimming pool, shop buildings, and extensive athletic grounds. The area to the west of Junipero Serra Boulevard was still largely undeveloped. The football field area formerly hosted dog racing and boxing matches. (Courtesy of DC/C HG.)

Three

DRAMA ON THE MOUNTAIN
1941–1960

Life was fairly placid for several decades in Daly City before World War II. People coped with the Great Depression, plied their trades, and developed a unique sense of camaraderie. John Daly's example of neighborliness was perpetuated.

The city celebrated its 30th anniversary in 1941, even as her young men were called into various branches of military service. Drama happened on the mountain during World War II when two U.S. Army Air Corps fighter planes crashed into its western slopes within hours of each other. Earlier, in August of 1942, Daly City made headlines across the country when a Navy patrol blimp landed on Bellevue Avenue, unmanned. The airship had been searching for enemy submarines off the California coast; its officers were never found. The story lingers on as "Daly City's Unsolved Ghost Blimp Mystery."

After the war, the mountain witnessed a time of phenomenal population growth, primarily through the endeavors of San Francisco builder Henry Doelger. Other builders of the era included George McKeon, Carl and Fred Gellert, and the Stoneson brothers.

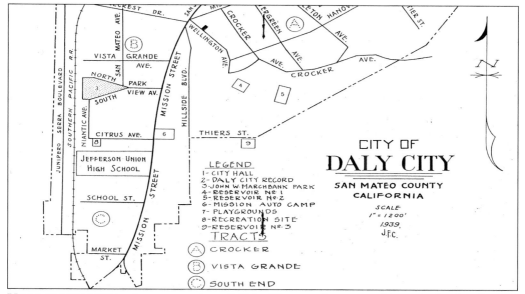

VITAL INFORMATION. Important sites of Daly City are shown on this end-of-a-decade map that appeared in Daly City's first Commercial and Civic Directory, subtitled "Gateway to the Peninsula." Published by the *Daly City Record* newspaper, included such statistics as "Area, 1079 square miles; Population, 12,000; Tax Rate: 80¢; Families, 3400; Registered Voters, 4584; Shopping Section, 10 blocks; Trade Section, four miles; Businesses, 250; Churches, five." The straight line across the top (north) indicates the county line between San Francisco and San Mateo Counties. (Courtesy of Gillespie collection.)

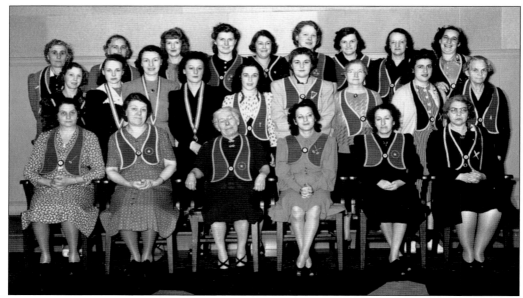

DALY CITY CLUBWOMEN. Officers of Daly City's Hillcrest Circle #143, United Ancient Order of Druids, donned their regalia for this 1941 photo. The organization, established in 1929, met regularly in the Masonic Hall. From left to right are (front row) Violet Hauptly, Agnes Prescott, Victorine Lombard, Hazel Keagle, May Milo, and Grace Hill; (middle row) Doris Craig, Ida Mae Lasswell, Viola Miller, Jennie Milo, Irene Rosenberg, Sally Watson, Mae Baker, Matilda Farbar, and Dora Holmberg; (back row) Clara Poket, Mary Crane, Marie Riley, Lillian Prescott, Eleanor Wilson, Minnie Lino, Winifred Evans, Margaret Gard, and Roselyn Rosenberg. (Courtesy of DC/C HG, courtesy of Hazel Hill Cargain.)

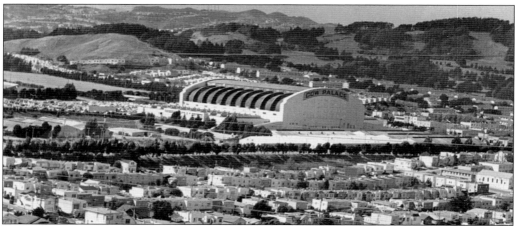

A PALACE FOR COWS. The Cow Palace took 26 years to bring to reality. In November 1941, the first Grand National Rodeo was presented there. Two weeks later, Pearl Harbor was attacked. For the next five years, the federal government rented the building for $1 a year. The Army took over the building for the duration of World War II. The Beatles invaded in 1964 to delight a sold-out audience with a 31-minute performance. Gleeful sounds became so deafening that anxious circus elephants housed in the adjacent north hall were forced to evacuate. The Cow Palace neighbors the Bayshore area of Daly City. (Courtesy of the Cow Palace.)

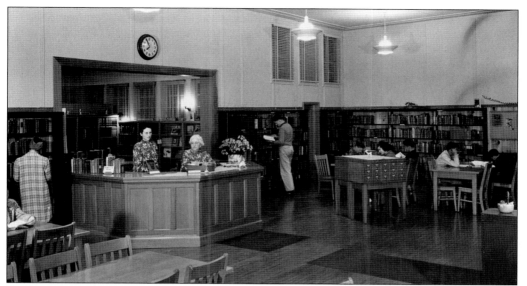

BOOKS FOR THE BORROWING. Librarian Jean O'Rourk (seated near the floral arrangement) and her assistant, Mary Zipser Lewis, welcomed patrons to the Daly City Library in this June 1941 photo. Flowers from Mrs. O'Rourk's nearby garden were daily delights in the building, which was completed in 1938. The library collection contained approximately 5,913 volumes, 20 periodicals and newspapers, 193 pamphlets, and 5,000 mounted pictures. (Courtesy of DC/C HG.)

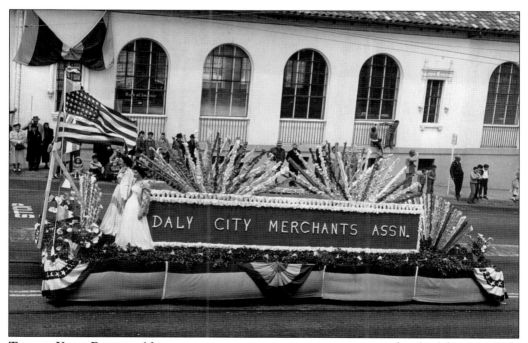

THIRTY YEAR PARADE. Never missing an opportunity to stage a parade of celebration, Daly City noted its 30th anniversary of incorporation in customary fashion on June 8, 1941. In the background of the Merchants Association float is the Bank of America at the apex of Mission Street and San Jose Avenue. (Courtesy of DC/C HG.)

BUSY DAY IN JUNE. The city got into recreation in a big way in the spring of 1941, when Lincoln Park at Acton and Brunswick Streets and Marchbank Park at Junipero Serra and Parkview were dedicated on the same day. At midday, between the two ceremonies, there was a lengthy parade between the two sites. In the afternoon, Owl Drugs' semi-pro team played an opening game against the Jefferson Alumni All-Stars at Marchbank. The entire city council (Paul Selmi, John Fahey, Henry Sundermann, Julius Twesten, and Edmund Cavagnaro) and many localites viewed the activities. (Courtesy of DC/C HG, donated by Walter Cavagnaro.)

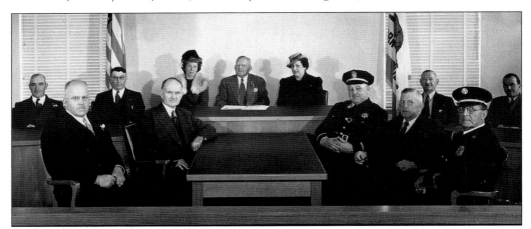

30TH ANNIVERSARY OFFICIALS. Daly City department heads and elected officials posed in the city hall council chamber for this 1941 committee portrait. The group was responsible for the elaborate program presented June 8 dedicating two parks and honoring Daly City pioneers. From left to right are Councilman Edmund Cavagnaro; Richard L. Crane, superintendent of Jefferson School District; Mayor John Fahey; James Ferguson, principal of Jefferson Union High School; Maisie Doyle of the recreation committee; Councilmann Henry Sundermann, chairperson for the big event; Ann Eason, recreation committee member; James Reardon, chief of police; Arthur Bodien, water department superintendent; Councilman Julius Twesten; Andrew J. Chesney, fire chief; and Councilman Paul Selmi. (Courtesy of DC/C HG.)

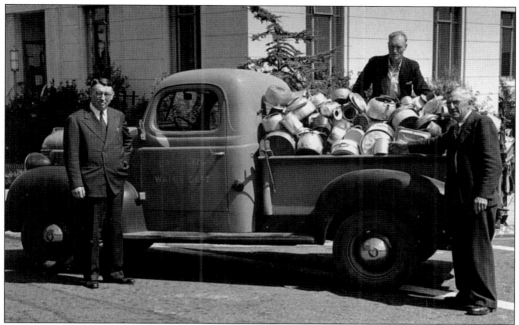

ALUMINUM FOR AMERICA. Homemakers donated over 420 pounds of kettles, pots, pans, sieves, baking sheets, and other household products to the July 1941 National Aluminum Drive. City trucks cruised the area accepting contributions. Shown at city hall are, from left to right, Mayor John Fahey; city employee Ed Olson; and water department superintendent Arthur J.Bodien, chairman of the Civilian Defense Council, previously called the Disaster Preparedness Committee. (Courtesy of DC/C HG.)

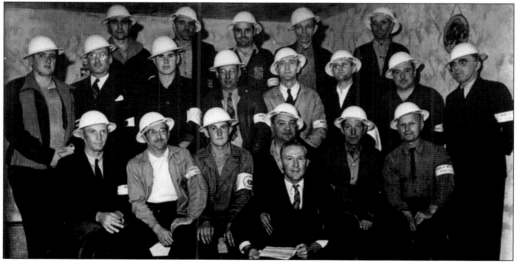

AMONG THE ALERT. Volunteers by the hundreds responded to the need for Civilian Defense Air Raid Wardens after a 44-minute blackout in January of 1942 plunged Daly City into total darkness just a month after the beginning of World War II. "Unidentified planes" had been reported in the area. Shortly after, the first armbands, flashlights, and bump hats were issued. Many of the younger men in this picture were later called to national service. (Courtesy of DC/C HG.)

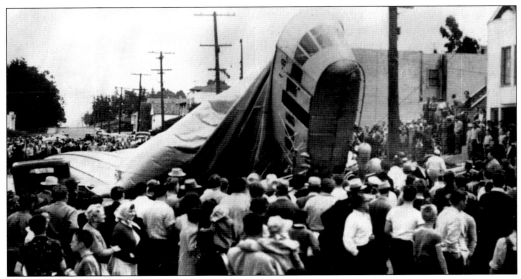

WORLD WAR II MYSTERY BLIMP. Making headlines and photo reports in newspapers across the country was the mysterious arrival of the unmanned U.S. Navy blimp L-8, which landed on Bellevue Avenue in the Crocker tract on Sunday morning, August 16, 1942. The airship, from the Treasure Island base, had been on anti-submarine patrol over local coastal waters, lost buoyancy, and drifted to Daly City, where it aimlessly floated over sand dunes and residences. Fascinated townspeople watched as Navy personnel found no sign of the craft's missing officers. The damaged balloon was repaired and returned to service, and the mystery remained forever unsolved. (Courtesy of Gillespie collection.)

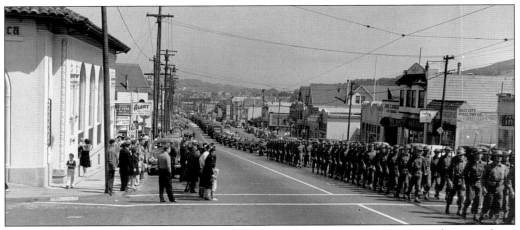

SHOW OF STRENGTH. Marching south in full parade dress on Mission Street, and approaching Wellington Avenue, were 200 members of Company L of the 184th Infantry, U.S. Army, in Daly City's World War II Civilian Defense Day parade on September 13, 1942. The men were followed by jeeps, trucks, mounted artillery, and anti-aircraft guns of the type being used on battlefronts at the time. The building at the left is the Bank of America, between Mission and San Jose Avenue at the Top of The Hill. The fifth building down the hill on the right is the post office with, strangely enough, no flag raised. The parade ended at the Jefferson Union High School athletic field. (Courtesy of DC/C HG, donated by Arthur J. Bodien, director, Daly City Civil Defence Council.)

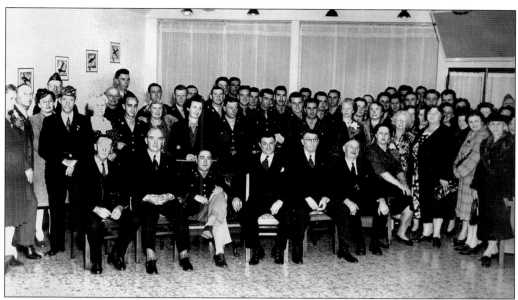

HELPING THE BOYS. Members of the American Legion, Veterans of Foreign Wars, city council, and the patriotically motivated gathered to launch a World War II service person's club at 6201 Mission Street, near Crocker Avenue, in 1942. Among those shown are Mayor Anthony J. "Tony" Gaggero, Councilmen John Fahey, Edmund Cavagnaro, and Julius Twesten. Lt. Mark Young and other soldiers represented several army installations then located in the area. (Courtesy of DC/C HG.)

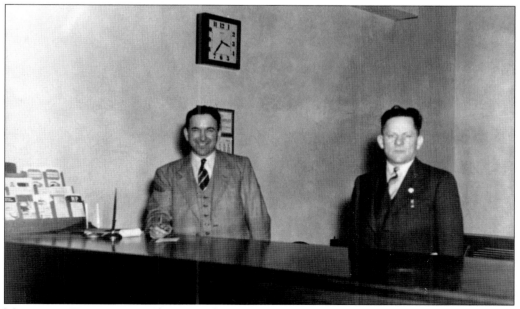

MEN WITH ENDURANCE. Shown at their office in 1942 are business partners William and Ricco Lagomarsino. Natives of Colma, the brothers' real estate and insurance business, established in 1926, served residents of both Colma and Daly City. (Courtesy of DC/C HG, donated by Loretta Lagomarsino.)

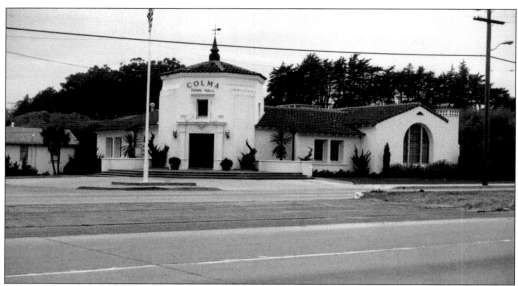

COLMA TOWN HALL. Leased from October 1943 to October 1944 during World War II to the Army Corps of Engineers, this town hall was completed in 1940. In November 1941, the town's name was changed from Lawndale to Colma. (Courtesy of DC/C HG.)

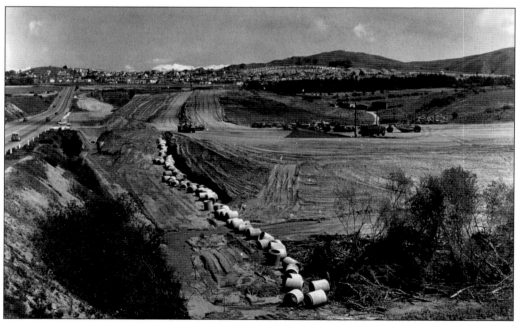

GETTING STARTED. In the Spring of 1947, land-grading operations started in a big way for development of Spring Valley Water Company acres into the planned community of Westlake. Equipment used for the 25-million-cubic-yard project included 13 powerful Allis-Chalmers TS-300 motor scrapers, 7 A-C HD-20 hydraulic torque converter drive tractors, and one A-C HD-9 tractor. The project was described as "mainly a series of cuts and fills with hauls averaging from 1800 to 4200 feet. Material is a clay, blue shale, gumbo, and drift sand combination." (Courtesy of DC/C HG, donated by Doelger Estate.)

MARCHBANK DIES. Daly City said "Thank you and good-bye" to John William Marchbank on December 1, 1947. He was 79 years old. The *San Francisco Chronicle* wrote of him, "he had become a legendary figure as a sourdough, gambler, rancher, businessman, turfman, political boss and philanthropist." Most depression-era children here remembered him for holiday parties at his theater, and invitations to reach into fishbowls of quarters while greeting him on the porch of his home. He left an estate of over $5 million. (Courtesy of Gillespie collection.)

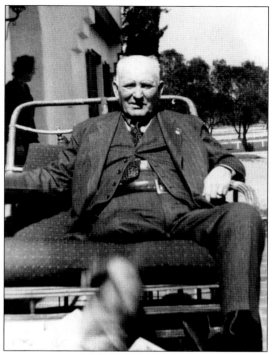

MARCHBANK'S HOUSE. After Jack Marchbank died in 1947, his house on San Jose Avenue near the Top of the Hill continued to be used as the publishing hub for the *Daly City Record*, one of his business enterprises. As years passed, new journalists were told of the "ghost" of Marchbank still residing upstairs in the building. The sound of his wooden wheelchair was said to be heard during quiet moments. Marchbank's other properties included a horse ranch in the East Bay. (Courtesy of DC/C HG.)

GARDEN CLUB SHOW OFFS. Displaying their elegant garden hats, decorated with real flowers, are 1948 members of the Daly City Garden Club. The club recognized outstanding local gardens and annually presented a two-day flower show in the First National Bank of Daly City offices on Mission Street. Shown (second from left) is the founder, Aimee Bunkley. The charter president was Elsie Martin (third from right, standing). (Courtesy of DC/C HG, donated by Elsie Garrison Martin.)

PLAYTIME AT BROADMOOR. Established in October of 1949, Broadmoor Community Nursery utilized a portion of the grounds at Broadmoor Presbyterian Church, 377 Eighty-seventh Street. The facility promised a "good character building program." Visible at the rear of the playground is one of Broadmoor Village's first homes on Eighty-eighth street, nestling against property prepared for row planting. Peaked farmhouses dot the area. (Courtesy of DC/C HG, Bill Koska photo, donated by Vic Guz.)

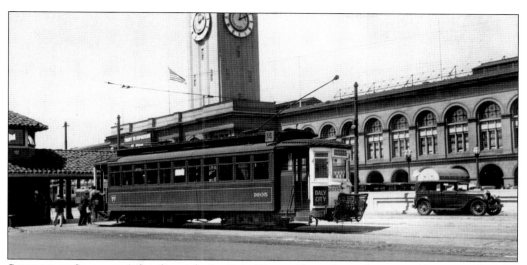

STREETCAR SERVICE. A familiar sight for Daly City residents depending on public transportation to and from San Francisco (or points along the way) was the #14 streetcar that traveled on Mission Street from the Top of the Hill to the Ferry Building in San Francisco. On holidays and Sundays, service was extended to cemeteries in Colma. Market Street Railway discontinued use of the #14 streetcar in 1949 when it launched its #14 trolley bus along the same Mission Street route. (Courtesy of Gillespie collection, donor Bill Ramroth.)

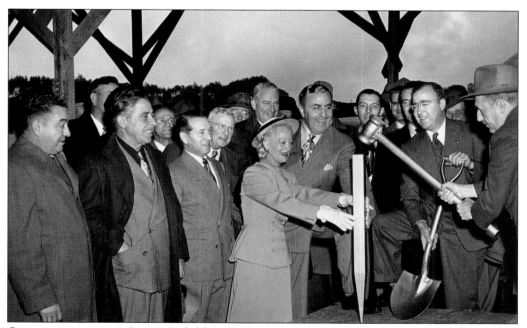

GROUNDBREAKING IN STYLE. Stylishly attired Thelma (Mrs. Henry) Doelger risks her fashionable wrist-length white gloves to steady a ceremonial spike at the March 1949 groundbreaking for Westlake Town & Country Shopping Center. While her husband beams, Mayor James Paul Green holds the gold-painted shovel and D.C. McGinnis prepares to pound. Onlookers included Elmer Kennedy, Milton Morris, Arthur Bodien, John Doelger, Frank Fullam, Bill Adams, and George Taylor. (Courtesy of DC/C HG, donated by Doelger Estate.)

WESTLAKE SIGNBOARD. Where Westlake Shopping Center would eventually be constructed, pipes and a large sign proclaiming the coming of Westlake waited on newly scraped land to the south of Alemany Boulevard in this October 1949 photo. Westlake Unit #1 is on the left. (Courtesy of DC/C HG, donated by Doelger Estate.)

PEEKING THROUGH THE CABBAGES. Open lands and agricultural endeavors with tidy rows of ripening cabbages along Skyline Boulevard to the west of what is now Westlake were soon to be items of the past, as indicated in this view of Henry Doelger's construction progress. Visible just over the trees to the left is Westlake Unit One, skirting John Daly Boulevard. With the advent of Doelger's massive project, Daly City's housing was to become concentrated on the west side of Junipero Serra Boulevard. (Courtesy of DC/C HG, donated by Doelger Estate.)

BUSY BUSINESS AREA. Junipero Serra Boulevard in the 1950s, between Eighty-seventh and Ninety-first streets, shows the commercial demands of a burgeoning population. As new homes were completed, more and more businesses opened to provide needed services. Some remain, but the Serra Theater was demolished in 1999. (Courtesy of DC/C HG.)

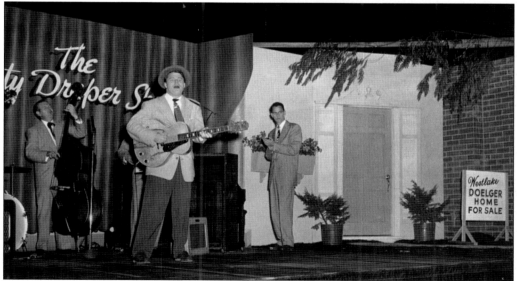

WHILE RUSTY PLUNKED. Residents of Broadmoor, Westlake, Colma, and countless other communities flocked to Westlake Shopping Center in the early 1950s to enjoy free Friday evening performances in the mall by noted performers. In addition to Rusty Draper, shown plunking his guitar and singing "Blue Tail Fly," attractions included Sal Carson, Eddie Peabody, Paul Speegle, Miss Universe (and many other crowned ladies), Clarabell the Clown from the *Howdy Doody* TV show, Popo the Clown, fashion, art, car, bridal, and flower shows, as well as giveaways. (Courtesy of DC/C HG, donated by Doelger Estate.)

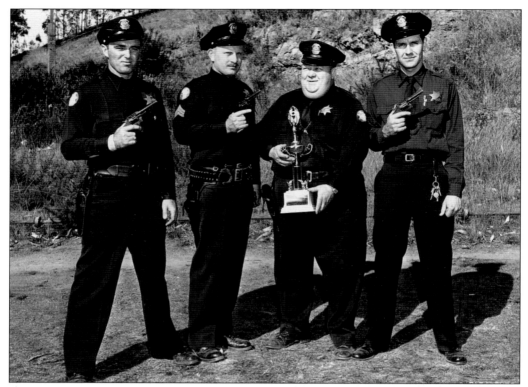

SHARP SHOOTERS. Taking a breather during target practice at Colma Gun Range in 1950 were Daly City police officers, from left to right, James Sunderland, David Hansen, James Welsh, and Jerry Schaffer. Sunderland's cap differs from others, denoting he was a motorcycle officer. Hansen was chief of police from 1974 to 1984. Schaffer later became a motorcycle officer before joining the California Highway Patrol. (Courtesy of DC/C HG, donated by Pat Hatfield.)

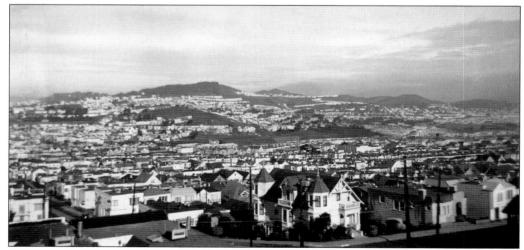

LOOKING NORTHWEST. Focusing on the landscape seen from the heights of Templeton Avenue in the Crocker tract is this 1951 view. The large Peterson residence at Peoria and Roosevelt Streets is in the foreground. (Courtesy of DC/C HG, donated by Mary Louise Becker Sharp.)

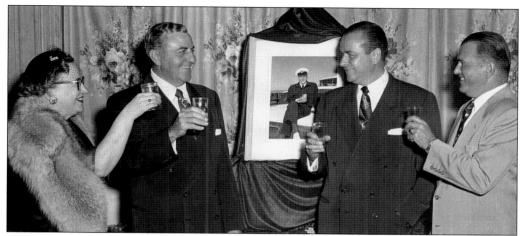

DISTINCTIVE DESIGNATION. In September 1952, Daly City achieved a bit of vicarious fame when Henry Doelger, developer of Westlake, was dubbed a "distinguished builder" by brewers of Lord Calvert Custom Distilled whiskey. The image of yachtsman Doelger perched on his Westlake II pleasure craft, as seen in this photo, appeared in full-page advertisements of the national *Collier's* magazine, outdoor advertising billboards, newspapers, and other avenues of full-scale promotion for the product. Shown in this photograph, from left to right, are Ms. Alpha Porter, secretary-treasurer for Doelger Corporation; Mr. Doelger; John Doelger, vice-president and general manager; and Bernardino Poncetta, vice-president of production. (Courtesy of DC/C HG, donated by Doelger Estate.)

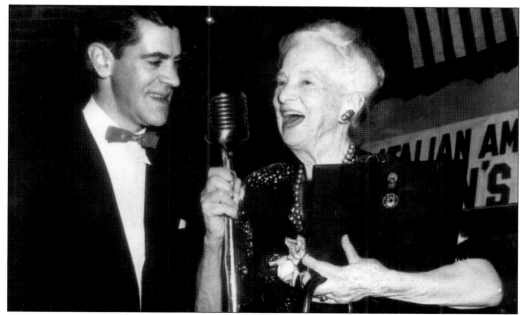

HONORS. Margaret Pauline Brown was visibly delighted at being named "Citizen of the Year" in May 1953 by the Daly City–Colma Italian-American Citizens Club. Presenter of the award was Dan Casentini, club president, who had been a student of the honoree. Mrs. Brown was a resident of the area for over 60 years and active in numerous welfare and charitable organizations. (Courtesy of DC/C HG.)

PIONEER TECHIE. E.M. "Bud" Matheny is shown in 1953 at the counter of his TV and radio store at 20 West Market Street. One of the earliest local businesses specializing in visual electronics, Bud's Radio & TV was operated by Mr. Matheny from 1951 to 1960, then sold to employee Bill Titus. (Courtesy of DC/C HG, photo by Dennis Matheny.)

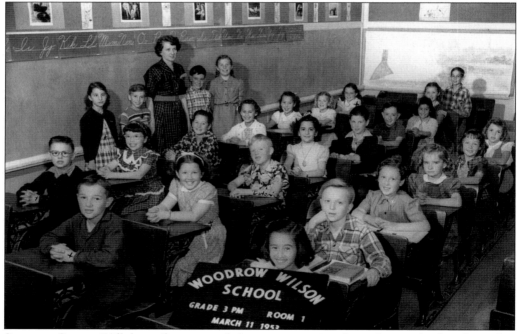

STUDENT SMILES. "All the smiles were made by everyone saying cheese," wrote third-grade teacher Ruth Rogers on the back of this 1953 photo of her class at Woodrow Wilson primary school on Miriam Street. Long a mainstay of Daly City's educational personnel, Mrs. Rogers further wrote, "Look in the mirror and say cheese. You will smile too!" (Courtesy of Gillespie Collection.)

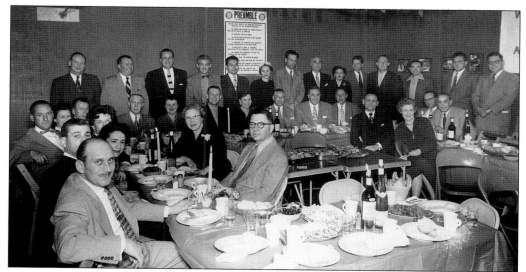

WESTLAKE WHEELERS AND DEALERS. Westlake entrepreneur and developer Henry Doelger (seated, center, above empty chair) gathered with members of the Westlake Business & Professional Association for this remarkable 1954 photograph of some of the people that helped bring commercial quality of life to Daly City's Westlake. Backing Doelger in the dark jacket is Ulysses R. "Jack" Kendree, Mr. Doelger's "right hand man" for many years. John Doelger is third from left, standing. (Courtesy of DC/C HG, donated by Al Belotz.)

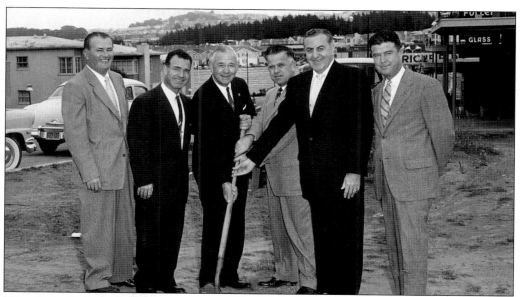

NEW POST OFFICE. The first new United States Post Office to be constructed in Daly City for many years was the Westlake branch on Southgate Avenue. With it, the ZIP Code 94015 would be used. Hands-on groundbreaking ceremonies in 1954 attracted, from left to right, Bernardino Poncetta; Joseph Verducci, mayor of Daly City; U.S. Congressman J. Arthur Younger; Daly City postmaster Vincent Murphy; developer Henry Doelger, and unidentified. Not surprising is the well-used look of the ceremonial shovel, considering the number of buildings being launched at the time in Westlake. (Courtesy of DC/C HG, donated by Doelger Estate.)

HENRY'S HEADQUARTERS. By 1955, Henry Doelger had achieved fame as one of the world's foremost homebuilders, completing six Westlake houses each day. Mr. Doelger's passion for his motor yachts, Westlake I, II, or III, is evidenced in the painting to his left and craft model to his right. The photo above the bookcase shows the 1,350 acres acquired in 1945. Earliest units cover most of the land. Mr. Doelger died in Italy in 1978. Some thought his development should have been named "Doelgerville." (Courtesy of DC/C HG, donated by Doelger Estate.)

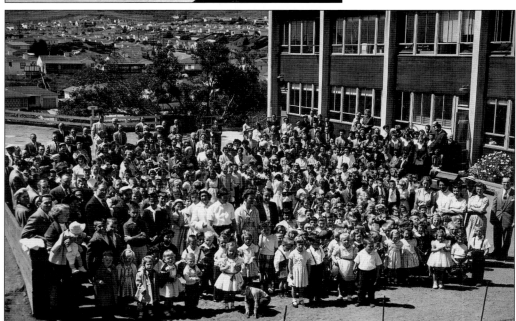

BROADMOOR BLESSINGS. As 1955 neared its close, Broadmoor Presbyterian Church's congregation had soared, with the Sunday school listing some 600 boys and girls. To the south, many homes had been built on rolling hills of Broadmoor Village. In the distance, remnants of farms and ranches were inviting development. In the doorway of education building is Rev. John A. Glasse, founding pastor. (Courtesy of Gillespie collection.)

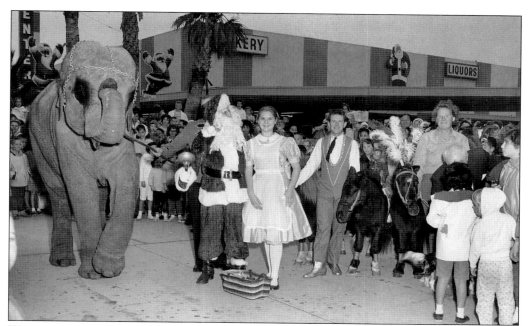

WESTLAKE WONDERLAND. Childhood fantasies were brought very close to home when Henry Doelger arranged a visit by Santa Claus, Alice (of Wonderland), Jumbo the Elephant, and feather-wearing ponies to delight visitors to Westlake Shopping Center in December of 1955. (Courtesy of DC/C HG, donated by Doelger Estate.)

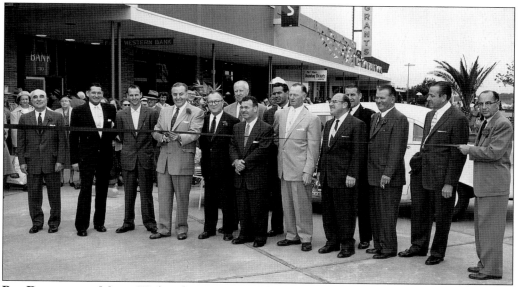

BIG DAY ON THE MALL. With a decisive snip of the ceremonial ribbon, Henry Doelger (in light suit, flower in lapel) opens yet another Westlake store in March of 1956. From left to right are U.R. "Jack" Kendree, Councilman Sanford Vickers, Councilman Michael DeBernardi, Mr. Doelger, George Roberts, City Manager Howard Stites, Mayor Joseph Verducci, Harty Rapp, Councilman Edward Dennis, Judge Frank Blum, Chief of Police Roland Petrocchi, Bernardino "Ben" Poncetta, John Doelger, and Ted Fallsgraph. (Courtesy of DC/C HG, donated by Doelger Estate.)

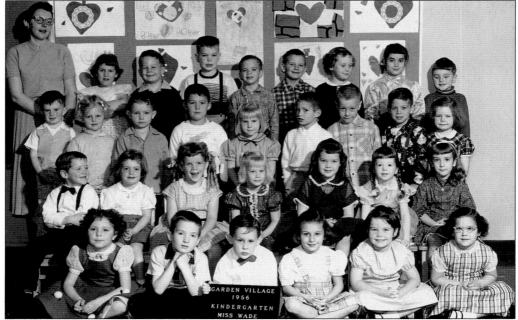

CLASS SIZES REFLECT GROWTH. This kindergarten class at Garden Village School in 1956 evidences increases in population experienced as new housing developments were continued or completed. Serving Broadmoor Village, Garden Village, Westlake, and students from other areas of Daly City, the school rented auxiliary classroom space in nearby Broadmoor Presbyterian Church on Eighty-seventh Street to accommodate an overflow of pupils. Wags, meanwhile, dubbed Broadmoor "breedmore." (Courtesy of Gillespie collection.)

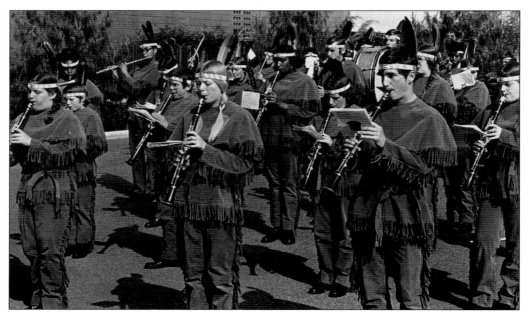

FRINGED CLARINETS. Long noted for developing musical talent, Jefferson Union High School's marching band wore these "Jefferson Indian" outfits with pride. (Courtesy of DC/C HG .)

SUMMER STROLL. Gene Ghio, owner of Boni Hardware, pauses on his evening walk as he passes offices shared by lawyer Harry H. Baier and the Colma Hog Raisers Association on West Market Street, in the summer of 1956. (Courtesy of DC/C HG, photo by Dennis Matheny.)

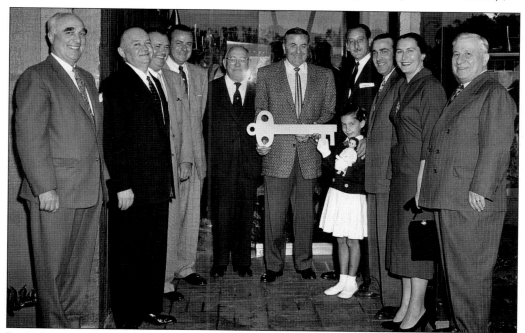

JOE'S COMES TO WESTLAKE. Opened on October 15, 1956, by Bruno Scatena, Joe's of Westlake quickly became a mecca for people that enjoy good Italian-style restaurant food and community ambiance. Holding the "Key to Cuisine" is Henry Doelger. Others include U.R. "Jack" Kendree, Bernardino "Ben" Poncetta, John Doelger, and the restaurateur. (Courtesy of DC/C H.G, donated by Doelger Estate.)

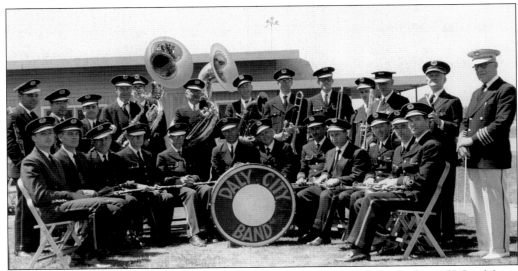

MUSIC MASTERS. The Daly City Municipal Band was among the delights at the 1957 San Mateo County Fair and Floral Fiesta, and wherever else they performed. Musical director George E. Brenner is shown at the far right. The band was chartered in 1930 with only eight members. It was a familiar sight at civic, fraternal, charitable, and patriotic affairs. No member of the band ever received any personal compensation for his services. (Courtesy of DC/C HG.)

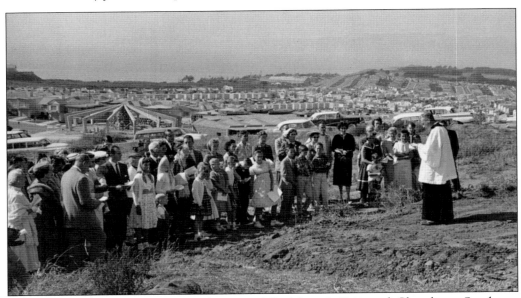

HIGH ON A PLEASANT HILL. Parishioners of St. Martin's Episcopal Church on Southgate Avenue broke ground for their new worship center in early September of 1957. In the background, Daly City homes sprawl over the landscape. Just above the crowd is the foundation for Vista Mar (later renamed M.H. Tobias) Elementary School's circular multi-use room. In the distance are Mar Vista stables and Olympic Golf Club. Officiating at the ceremony was the Right Rev. Karl Morgan Block, bishop of California, assisted by Rev. Allen J. Downey, vicar of St. Martin's. Finding it unwieldy, the name of the church had been changed from "St. Martin's Mission, Episcopal." (Courtesy of DC/C HG, donated by Doelger Estate.)

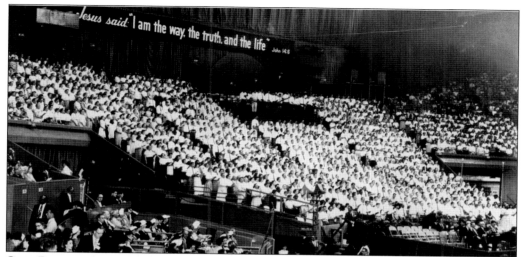

COW PALACE CRUSADE. Daly City churches volunteered musically talented members of their congregations to form this remarkable 1,500-voice inspirational choir when the noted Christian evangelist Billy Graham brought his "Hour of Decision" radio program and month-long religious crusade to the Cow Palace on Geneva Avenue in the spring of 1958. Featured celebrity singers included Ethel Waters and George Beverly Shea. (Courtesy of Gillespie collection.)

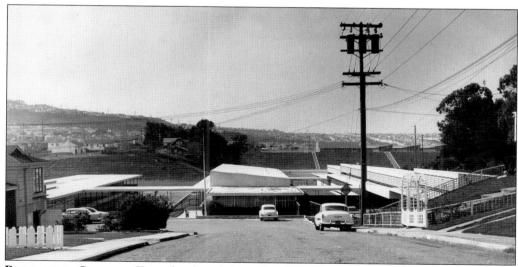

BROADMOOR SCHOOLS. Two schools and the rolling hills of Broadmoor Village (unincorporated Colma) are seen in this 1958 photo. In the foreground is Garden Village Elementary School, 208 Garden Lane at Colma. Directly to the west is Benjamin Franklin Middle School, 700 Stewart Avenue. The large house nestling among trees in center was the Shinazy residence. (Courtesy of Gillespie collection.)

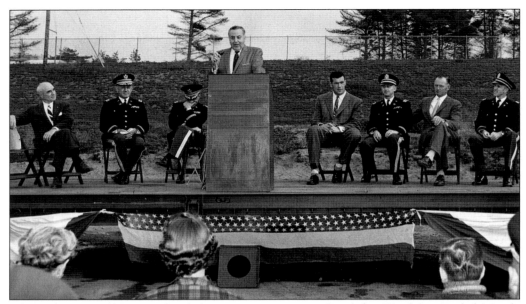

IMPRESSIVE CEREMONIES. The dedication in January 1959 of the Westlake Guided Missile Battery Site off Skyline Boulevard near the Olympic Club attracted military, political, and business officials. The site was previously known as the Battery A, 4th Missile Battalion Site. From left to right are U.R. "Jack" Kendree, manager of Westlake Shopping Center; Lt. W.W. Buckingham; Col. M.M. Irving, chief of staff of the 6th Army Region; builder Henry Doelger, at podium, Councilman Robert St. Clair; builder Henry Doelger; Councilman Edward J. Dennis, and Capt. H.A. Clark, battery chaplain. (Courtesy of DC/C HG, donated by Doelger Estate.)

HISTORICAL TEA SERVICE. With Mrs. Jesse Glasse doing the honors, refreshments were happily received as Broadmoor Presbyterian Church put into use the splendid silver tea service bequeathed in 1959 to the congregation. The donor was parishioner Margaret Pauline Brown, widow of California assemblyman (1899–1903, 1911–1915) Henry "Honest" Ward Brown. Pioneer residents of Colma, they had been given the silver on his retirement from the state assembly. (Courtesy of Gillespie collection, photo by Art Frisch.)

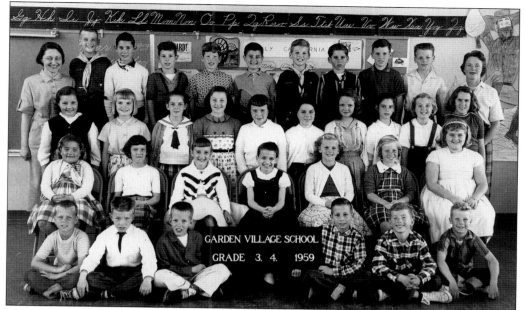

TWO IN ONE. Grades three and four shared a classroom at Garden Village School during the 1959 instructional year. From left to right are (front row) Greg Raymond, Ricky Hammond, Doug Wittington, Dennis Buell, Joe Ferneckes, and Larry Landis; (second row) Nancy Bradshaw, Cynthia Precenis, Perky Gillespie, Diane Bruch, Carol Widfeldt, Debbie Phillips, and Kathy ?; (third row) Karen Anderson, Betty Hotchkiss, Denise Teffault, Claudette Greenfield, Diane DuMont, Linda Henry, Mary Francis Patterson, Barbara Feld, Gabrielle Pipe, and Connie Manis; (fourth row) teacher Miss Walden, Greg Deal, Ronny Brussel, Cliff Warner, Paul ?, Steve Blake, Marty Warmouth, Joel Weinberg, Mike Thomas, Rex Arnott, and teacher Mary Lewis. (Courtesy of Gillespie collection.)

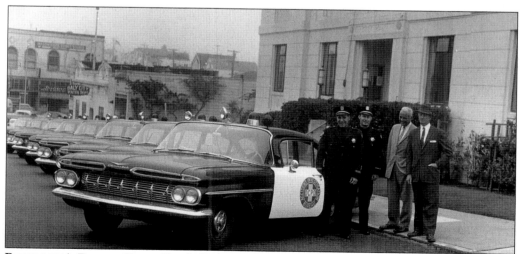

PETROCCHI'S PATROL CARS. Chief of Police Roland Petrocchi, nearest the Accident Investigation Bureau vehicle, checks Daly City's fleet of cars in front of the city hall on Wellington Avenue in 1959. Shown with him are, from left to right, Assistant Chief Roy McLaren; George Watts, city manager; and Ed Dennis, mayor. (Courtesy of DC/C HG.)

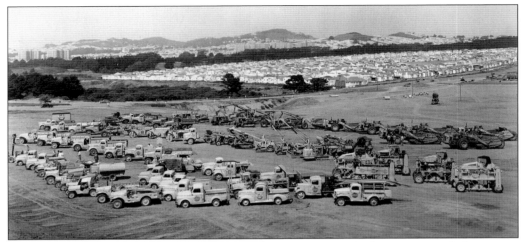

IMPRESSIVE LINEUP. This remarkable array of construction vehicles represented about one-third of Henry Doelger's fleet of trucks, graders, and other types of building equipment during the 1950s. Most of them bear the distinctive green and cream Doelger logo. (Courtesy of DC/C HG, donated by Doelger Estate.)

TASTY TRADITION. Use of this oversized mock birthday cake was an annual event in the Westlake Shopping Center mall as the facility celebrated its success with the community by serving free refreshments. Started in 1952, the tradition continued for many years. (Courtesy of DC/C HG, donated by Doelger Estate.)

Four

THE MOUNTAIN WELCOMES
1961–1985

Daly City celebrated its golden anniversary in 1961 in great style, with events involving every aspect of its now-urbanized lifestyle. Replacement of sand dunes, hog havens, and a wide variety of agri-businesses continued.

The city welcomed a unique recreational facility in 1978 when over 2,000 acres of San Bruno Mountain's main ridge were developed into San Bruno Mountain State and County Park. Some of the mountain's longest-tenured residents had been designated as endangered, including the San Francisco garter snake, and Mission Blue, Elfin Blue, and Silverspot butterflies.

As land in the valleys and slopes of San Bruno Mountain became more and more filled with homes, schools, businesses and other accouterments of civilization, the need for improved methods of transportation became apparent. By now, most of the area's burgeoning population was employed outside of Daly City. Bay Area Rapid Transit (BART) opened a Daly City terminus in 1977. A Colma station would open in 1996.

SUBDIVISION STARTS. As the new decade opened, the first homes of the St. Francis Heights development were being completed. In the foreground is old Edgemar Road, changed later to Eastmoor Avenue. Earth-moving equipment waits at the site for Margaret Pauline Brown Elementary School. (Courtesy of DC/C HG.)

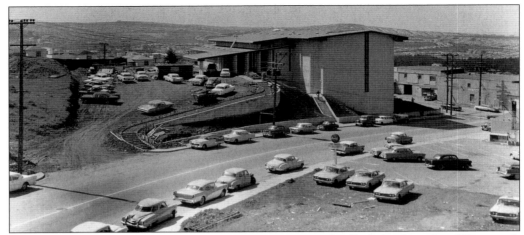

MORMONS ON A HILL. Completed in 1961 at the corner of Hillside Boulevard and Brunswick Street, this impressive building is home for several congregations of the Church of Jesus Christ of Latter-Day Saints, or Mormons. At the right are sheds formerly used by Smith Lumber Company. In the background sprawl Westlake and Broadmoor housing developments. (Courtesy of DC/C HG.)

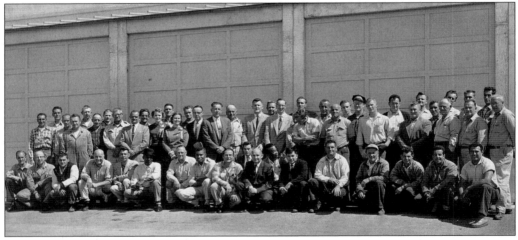

PUBLIC WORKS DEPARTMENT, 1961. This heroic photo shows the people that kept Daly City operational, through good days and bad. Shown are members of the building, engineering, garage, parks, maintenance, streets, and water departments. From left to right are (front row) Henry Black Jr., Verne Simpson, John Vallurga, Joe Intashi, Bill Gfroerer, Arvid Peterson, Bennie Toliver, Reginald Calvert, Paul Bostrom, Gene Myers, Wai Wong, Stanley Solamilio, Luis Ramirez, Amadeo Gonella, William Byrne, George Valente, and Henry Rendon; (back row) Frank Ramos, Walter Mermon, Norman Densmore, Tom Eichner, John Peterson, Natalino Gaggero, Joseph Gerack, Joe Bloem, Henry Weisner, Guido Lucchesi, Betty Anderson, Edward Duncan, Janet Leaskou, Lloyd Tindle, Maurice Clark, George Hoppman, August Conci, William Chapman (city engineer/department head), Michael Lemke, Edward Dominion, William Chalmers, Albert Bender, Harry Krohn, Albert Perada, George Beutler, Earl Dunphy, Ray Moore Jr., David Cafferata Jr., Albert Lewis, Frank Rehe, Alois Schiessl, Gus Ford, William Haynes, Harold Turner, Frank Davison, Neil Pezzola, and David Cafferata Sr. (Courtesy of DC/C HG, donated by Russell Brabec.)

JEFFERSON ADJUSTMENTS. With San Bruno Mountain dominating the northeast, and Seton Medical Center looming large on a nearer rise, Thomas Edison School, at 1267 Southgate Avenue, was opened in 1961 to serve St. Francis Heights and Westlake students. Neighbors to the school on the same square block are Fernando Rivera School, at 1255 Southgate, and the Jefferson ES District education center, at 101 Lincoln Avenue. Adjusting to the needs of the academic community, Fernando was formerly located at 101 Lake Merced Boulevard. Edison was previously at 1255 Southgate. The Abraham Lincoln school, at 1267 Southgate, was lost in the shuffle. (Courtesy of DC/C HG, photo by Frank Franceschini.)

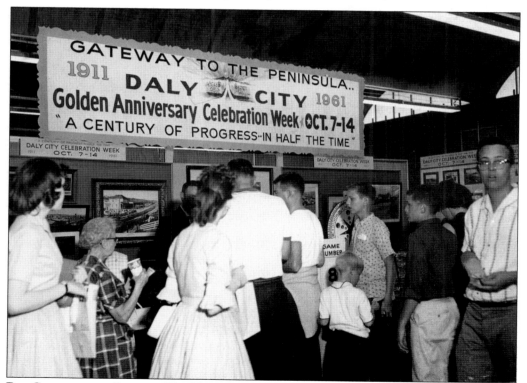

BIG CELEBRATION COMING. Heralding the upcoming 50th anniversary of incorporation was a special display of historic photos and giveaway prizes in Fiesta Hall at the San Mateo County Fair. For years, Daly City staffed an information booth at the annual fair. (Courtesy of DC/C HG.)

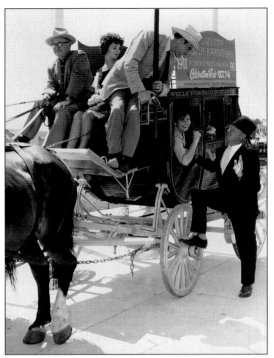

GOLDEN ANNIVERSARY FUN. Former Daly City mayor Edward J. Dennis (1959–1960) strikes an unlikely pose in his derby hat and dark suit for this 1961 pre-parade photo promoting the celebration week noting 50 years since city incorporation in 1911. The pretty girl next to driver is Lynette Fischel, Miss Daly City for 1961. A stagecoach replica was borrowed for the festivities from Wells Fargo Bank. After the parade, free rides in the coach were offered to children. (Courtesy of DC/C HG.)

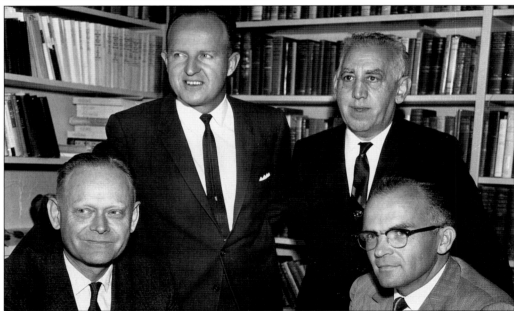

MINISTERIAL PLANNING. Preparing for a festival of church music to be presented in October 1961 as part of Daly City's golden anniversary celebration were from left to right, Rev. Herbert C. Tweedie, of Broadmoor Presbyterian Church; Rev. Lynn Hodges, Westlake Community Baptist Church; Rabbi Solomon A. Shore, Temple B'nai Israel, and Rev. Clark Robb, Seacliff Community Church. Held at the War Memorial Building on Mission Street, the event included a 150-voice mixed choir, church soloists, and musical accompaniment. (Courtesy of Gillespie collection.)

DALY CITY SALUTES. More than 500 people gathered at the War Memorial Building on Mission Street in September of 1961 to salute the city's former mayors and city councilmen. The banquet was the largest event of its kind ever held in Daly City, and it was the last of a series of events leading up to Daly City's golden anniversary celebration. Dignitaries included Congressman J. Arthur Younger and State Senator Richard J. Dolwig. (Courtesy of DC/C HG.)

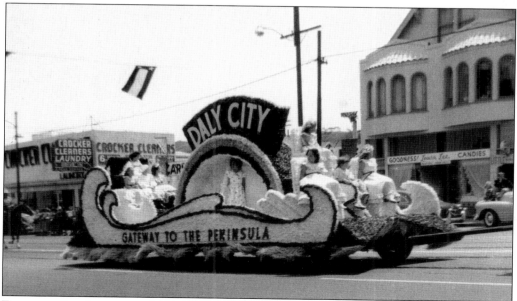

FLOATING BY. An estimated 100,000 people watched Daly City's anniversary parade on October 7, 1961. The event included 130 units, not the least of which was this splendid theme float. The line of march continued for 2 hours, ultimately passing a reviewing stand constructed in front of Jefferson High School on Mission Street. (Courtesy of Gillespie collection.)

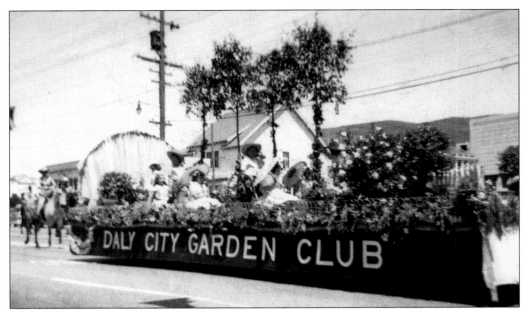

GARDEN CLUB SALUTE. Girls with long dresses and parasols and boys with country-style wide-brim straw hats tossed flower petals from this Garden Club float during Daly City's anniversary parade. (Courtesy of Gillespie collection.)

CELEBRATION CHARMERS. Laden with roses were two of the young ladies that graced Daly City's 50th anniversary celebration: Penny Bertsch of the Daly City Hi Fi Teen Club (in white swim suit) and Lynette Fischel, Miss Daly City for 1961. With them are Councilman Michael DeBernardi; Mrs. Melford Battye, Mrs. Daly City for the celebration; Councilman Edward J. Dennis; Mayor Pro-tem Joseph Verducci, and Councilman Frank Pacelli. (Courtesy of DC/C HG.)

FROSTED FUN. Youngsters slid down a snowy slope at Westmoor High School when an early-morning white surprise brightened a Sunday in 1962. Make-do "sleds" were improvised, utilizing metal garbage can lids, rubber inner tubes, and flattened cardboard packing cases. The *San Francisco Chronicle* featured this picture on its front page the next morning. (Courtesy of Gillespie collection, photo by Art Frisch.)

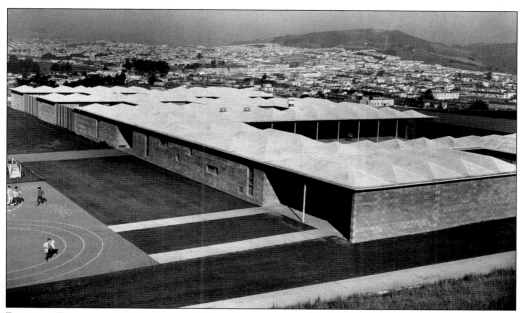

PIONEER EDUCATOR REMEMBERED. The achievements of one of Colma's earliest educators were honored in February 1962 as sixth-grade students presented the debut performance of the Margaret Pauline Brown School song, written for the PTA's initial Founder's Day observance. The school at 395 Eastmoor Avenue had opened in November of 1961. The building was designed by the award-winning architect Mario Ciampi. (Courtesy of Gillespie collection.)

PASSING THE GAVEL. With City Manager Edward Frank looking on, Daly City's 1961 mayor Robert "Bob" St. Clair passes the symbol of Daly City's highest office to 1962 Mayor Joseph Verducci at Daly City's City Hall on Wellington Avenue. Mr. St. Clair holds the unique distinction of having been the captain of the San Francisco '49ers professional football team during his term of office as mayor. (Courtesy of DC/C HG.)

EXECUTIVE ALLIANCE. In an office crowded with floral tributes, and exhibiting a characteristic smile, Ed King accepted the good wishes of his former business associate Carl Wente (left), then president of the Bank of America. In March of 1962, Mr. King had been named corporate vice president and general manager for Henry Doelger Builder Inc., continuing a long business acquaintance. While a bank manager in Daly City, "Eddie" had handled the Doelger business bank account as well as the financing for Westlake homebuyers. After Mr. Doelger's death in 1978, Mr. King became executor of the Doelger Estate. (Courtesy of DC/C HG, donated by Doelger Estate.)

RADIO ROAD. Prior to the 1962 development of the four-lane Guadalupe Canyon Expressway, Radio Road provided a bucolic route from "civilization" below to the top of San Bruno Mountain. Continuing east, travelers enjoyed a winding way from Colma to Brisbane. (Courtesy of DC/C HG.)

SUMMERTIME FUN. Enjoying a watermelon feed under the auspices of the recreation department in July of 1962 are these enthusiastic youngsters at Westlake Park. (Courtesy of DC/C HG.)

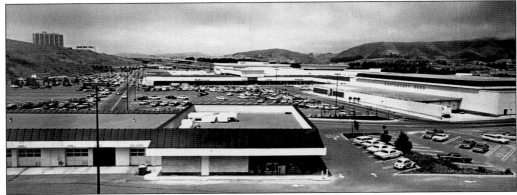

SERRAMONTE CENTER. For over 100 years, the Colma Valley property first claimed by Patrick Brooks in 1853 had changed ownership several times. In 1963, Christen Dairy Ranch operations on the land ceased. The area was annexed to Daly City, renamed Serramonte, and developed into homes and this large shopping center. (Courtesy of DC/C HG)

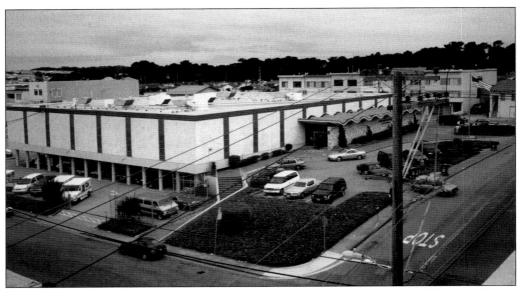

MAIN POST OFFICE. Attempting to keep pace with the geographic center of the population, the main branch of the Daly City Post Office was moved in 1964. Typically, the parking lot at the Eighty-eighth Street and Sullivan facility is filled with patrons' vehicles. The previous headquarters had been at the Top of the Hill. (Courtesy of Gillespie collection.)

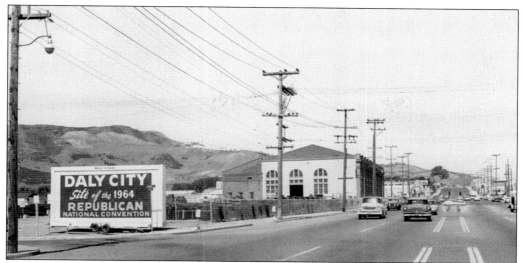

NATIONALLY CHOSEN. Geneva Avenue in the Bayshore Section of Daly City was to see itself on big time television in 1964 when the Cow Palace, just to the west in this photo, hosted a national political convention. The event nominated Barry Goldwater of Arizona as the GOP candidate for President of the United States. The large building in center is a Pacific Gas and Electric facility. (Courtesy of DC/C HG.)

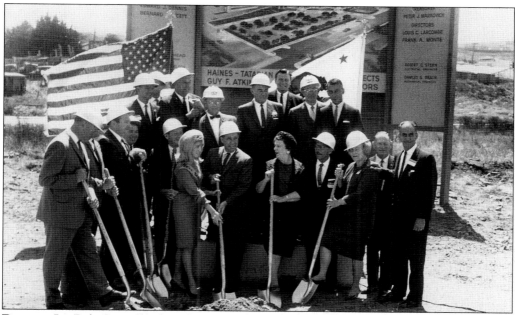

DIGGING IN. Daly City officials and well-wishers surrounded Mayor Francis "Frank" Pacelli in this 1965 ground breaking activity prior to construction of a new civic center at Eighty-eighth Street and Sullivan Avenue. The $3.5-million complex would be dedicated two years later. Pictured here are, from left to right, Councilman Edward J. Dennis; unidentified; Mayor Pro-tempore Albert E. Polonsky; unidentified; Councilman Bernard J. Lycett; Susan Bernard, Miss Daly City; the mayor; Anne Eason of the historical committee; unidentified; Anna Ohlendorf, city clerk; Edward Frank, city manager, and Joseph Lewkowitz, city treasurer. (Courtesy of DC/C HG.)

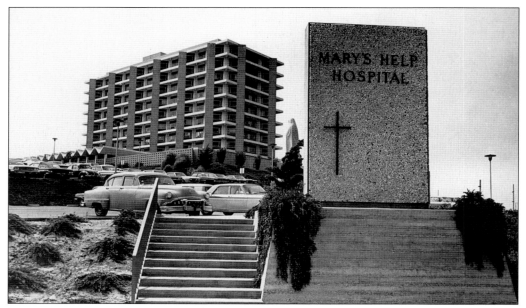

MARY'S HELP HOSPITAL. Two and a half years in construction, Mary's Help Hospital was dedicated on December 18, 1965, on a hillside site previously used for raising heather and field crops. The main entrance façade is said to "capture the design of the Daughters of Charity cornette." (Courtesy of DC/C HG.)

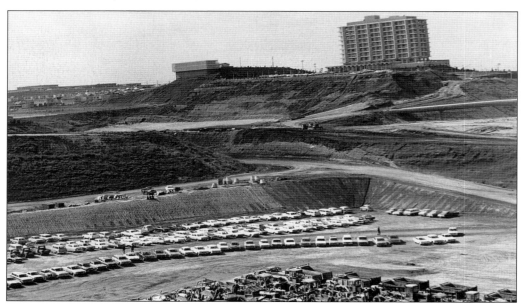

ONCE-IN-A-LIFETIME PHOTO. This remarkable image was commissioned in 1966 by the Buzz Haskins Construction Company for use in promotional brochures. Cheek by jowl is the amazing fleet of vehicles then being utilized by Haskins' workers. On the horizon, from left to right, are Westmoor High School, Calvary Cross Church, and Mary's Help Hospital (later renamed Seton Medical Center). Not yet developed are extensions of Sullivan and Southgate Avenues. (Courtesy of DC/C HG.)

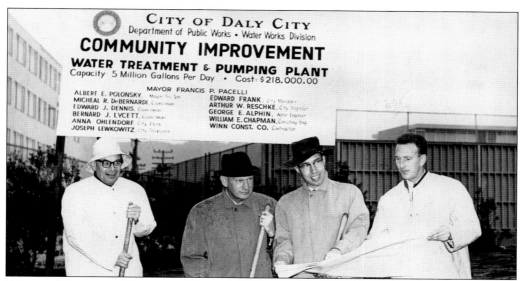

TYPICAL WEATHER. Water was not one of Daly City's most pressing problems in the winter of 1966, as this rainy-day February photo testifies. Braving torrential elements to break ground for the new Westlake water treatment and pumping station were, from left to right, William Indig, president of Winn Construction Company; Edward Frank, city manager; Arthur W. Reschke, city engineer; and George E. Alphin, water supervisor. Of the event, the *Daly City Post* reported, "there is no truth to the rumor that the quartet floated away from the scene in an ark skippered by a gentleman named Noah." (Courtesy of DC/C HG.)

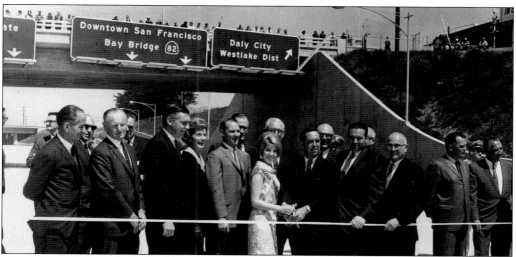

FREEWAY DEDICATION. Greatly welcomed by residents of Daly City was the opening of the Interstate 280 Freeway, dedicated on April 14, 1966, with smiles and ceremonies. Shown here, from left to right, are unidentified; Joseph Lewkowitz, city treasurer; unidentified; Edward J. Dennis, councilman; unidentified; Leo J. Ryan, state assemblyman; Jean Fassler, mayor of Pacifica; Michael DeBernardi, councilman; Edward Morgan, superintendent of Jefferson School District; Susan Bernard, Miss Daly City; unidentified; Frank Pacelli, mayor; unidentified; Albert Polonsky, mayor pro-tempore; unidentified; Mike Wilson, city hall staff; and Pete Markovich, manager of chamber of commerce for Daly City and Colma. (Courtesy of DC/C HG.)

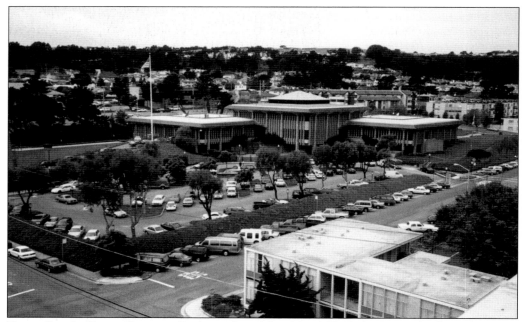

DALY CITY'S CIVIC CENTER. Dedicated on May 20, 1967, Daly City's third city hall and government complex at 333 Ninetieth Street was constructed on a four-acre site in the middle of the $75 lot Homestead subdivision, formerly used almost exclusively for growing vegetables and flowers. The area was originally mapped and divided into 25-foot lots in 1870. (Courtesy of Gillespie collection.)

MUSICAL TRIBUTE. The opening of Daly City's new civic center brought out a galaxy of talent, including the Jefferson and Westmoor High School student bands. Director Richard Larsen (at far right) kept a watchful eye over his young musicians while keeping the beat. (Courtesy of DC/C HG.)

CELEBRITY PHOTO-OP.
Daly City's handsome civic
center provides a rock-solid
background for this publicity
shot taken in 1967 when movie
star Eddie Albert came to town
as Grand Marshal for that year's
Grand National Rodeo at the
Cow Palace. With him as he
tips his Stetson are, from left to
right, Councilman Ed Dennis;
Mayor Bernard Lycett, holding
plaque; and Councilman
Anthony Giammona. (Courtesy
of DC/C HG.)

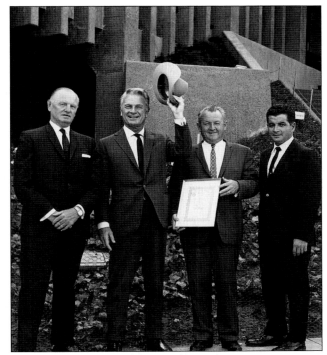

LAST OF A TYPE. Still sheltered by San Bruno Mountain to the east, these buildings give mute evidence to thriving ranching activities that flourished in the Colma hills for many years. This 1967 view was taken just prior to demolition. At one time, Colma was credited as being the home for some 45,000 hogs. (Courtesy of DC/C HG.)

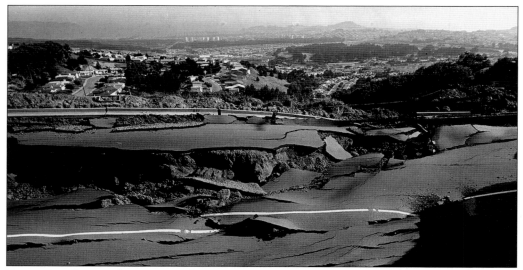

EASTMOOR WOE. All was not well on Eastmoor Avenue just north of Westmoor High School in August of 1968 when this definitive photo was taken following a sudden road cave-in between Edgemont Avenue and St. Francis Boulevard. Sliding sand and debris endangered homes in adjacent Broadmoor Village, caused evacuation of 25 people, ruptured a water main, and engendered lots of raised eyebrows. Note Eastmoor's displaced steel guardrail and sectioned white median line. (Courtesy of DC/C HG.)

LOVE LADIES. Holding their L-O-V-E letters, these spoofers of the 1960s love generation are members of United Presbyterian Women at Broadmoor Presbyterian Church on Eighty-seventh Street. From left to right are Mmes. Frieda Clark, Myrtle Woodcock, Julia Rued, and Sibine Fairbanks, each of whom were usually much more sedate than this photo might suggest. (Courtesy of Gillespie collection.)

WINDING WAY. Starkly beautiful, San Bruno Mountain has long provided a respite from urban lifestyles. In this 1970s photo, the solitary horse at the far left might well be contemplating his future. (Courtesy of DC/C HG.)

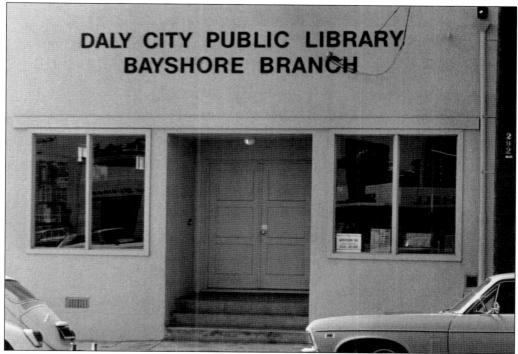

BAYSHORE BRANCH. The smallest of the four branches of the Daly City Library, Bayshore serves readers living in the sun belt near the Cow Palace. Their first library was opened in July of 1964 at 129 Acacia Street, with 4,000 books. Nine years later the facility was moved, with 14,000 volumes, to 2960 Geneva Avenue. This photograph is c. 1973. (Courtesy of DC/C HG.)

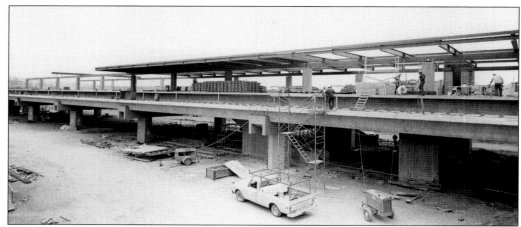

BART UNDER CONSTRUCTION. Workmen hurried in 1972 to make progress on the BART terminal at Junipero Serra and John Daly Boulevards. After delays, passenger service between Montgomery Street (in San Francisco) and Daly City began on November 5, 1973. (Courtesy of DC/C HG.)

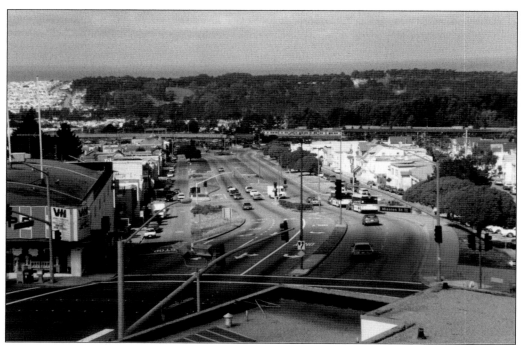

BART BRINGS CHANGES. Uniquely affecting residents of Daly City was the 1973 opening of the BART system terminal. To accommodate increased traffic, two of the area's oldest thoroughfares were widened into a six-lane boulevard leading from Mission Street near the Top of the Hill to the 14-acre station adjacent to Highway 280. Taken for the widening project were homes on the south side of Los Banos Avenue and the north side of Knowles Avenue. The widened street was named John Daly Boulevard, connecting at Junipero Serra Boulevard with the western side of John Daly Boulevard, previously called Alemany Boulevard. Trees in the west are part of Lake Merced and Olympic golf courses. (Courtesy of Gillespie collection.)

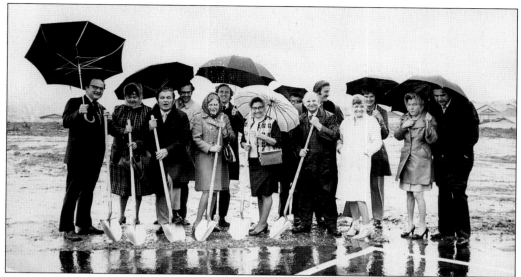

WET AND WONDERFUL. Even a typical rainy day in Daly City couldn't dampen the enthusiasm of these participants as ground was broken for the construction of the Serramonte Branch of the Daly City Library on November 20, 1973. The building would be the fourth of Daly City's library facilities. Shown, from left to right, are Victor Kyriakis, councilman (with inside-out umbrella); Verna Teglia; Mayor Tony Giammona; James Sargeant; Virginia Tierney; Dr. Connolly; Sarah Kelchava; unidentified; Samuel Chandler, librarian; three unidentified persons, Velma Yule, and Councilman Al Teglia. (Courtesy of DC/C HG.)

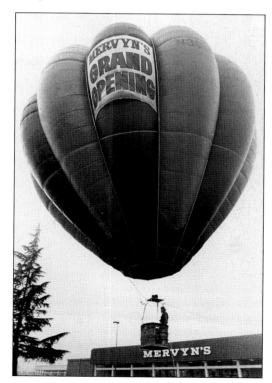

BIG TIME OPENING. Serramonte Shopping Center was fast becoming a hub for mall-meanderers and sale-seekers when Mervyn's raised this gigantic advertising balloon in October of 1973. (Courtesy of DC/C HG.)

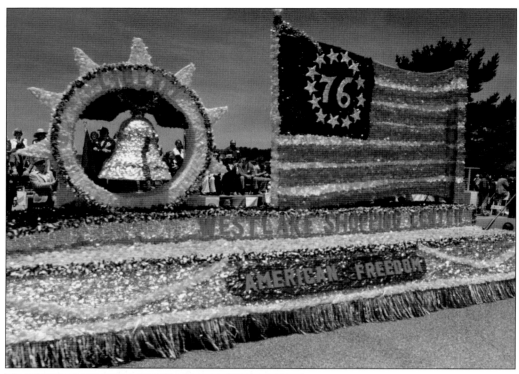

CELEBRATING THE U.S.A. An estimated 25,000 spectators watched over 5,000 participants in Daly City's largest-ever parade on Sunday, June 13, 1976, in celebration of the nation's bicentennial. The colorful, flag-waving, three-hour, red, white, and blue event was given cheers and applause all along the route. (Courtesy of DC/C HG, donated by Alfred O. Belotz.)

THANKS TO BIG AL. An excellent choice was made when Daly City's Bicentennial Parade Committee nominated energetic Alfred O. Belotz as chairman for the 1976 event to honor the United States' 200th birthday. Mayor Tony Giammona (at right) had opened the march down John Daly Boulevard, and later beamed as he presented the appreciation of a grateful city at a council meeting. (Courtesy of DC/C HG, donated by Alfred O. Belotz.)

TEACHERS THREE. Still friends in 1978 were these three women of the Daly City educational community, from left to right, Mrs. Margaret Syme Clarke McCaffrey, Miss Henrietta Engel (seated), and Mrs. Lillian D. Fletcher, all of whom were involved with the earliest years of the Parent Teacher Association serving General Pershing School. Mrs. McCaffrey taught at Pershing, Crocker, and Washington schools, retiring in 1970 after 42 years as an educator. Miss Engel, nicknamed Henry by other faculty members, was the kindergarten teacher from 1918 to 1935. Mrs. Fletcher was the 1929 charter president of the PTA. She taught in a one-room school at Brattleboro, Vermont, before arriving in California and at Hillsborough School (San Mateo County) during World War II. For many years, she was a classroom teachers' aide in the Jefferson District. The trio was honored in 1978 at the closing of Crocker and Pershing schools. (Courtesy of Gillespie collection.)

HOME PRIDE. A recognition project of the Property Owners Association for over a decade, the honor of displaying this sign was the reward for outstanding horticultural endeavors in Broadmoor during the 1970s. (Courtesy of DC/C HG.)

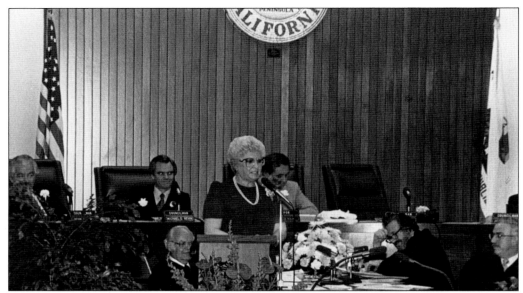

FIRST WOMAN COUNCILPERSON. A giant step for feminism was made in 1980 when Mrs. Jane Powell was the first woman chosen to serve on the city council. She became mayor in 1982–1983, 1986–1987, and 1991–1992. Shown on the dais are, from left to right, Councilmen Anthony "Tony" Giammona, Michael "Mike" Nevin, and 1981–1982 Mayor Albert "Al" Teglia. In the foreground are installing judge Dannom and City Attorney Al Polonsky. (Courtesy of DC/C HG.)

THORNTON STORM DAMAGE. Following torrential rainstorms that pounded Daly City for days in January 1982, damage to the area was notably severe. At Thornton Beach State Park, major landslides occurred and extensive damage disrupted use of the facility. Former drainage structures may be seen to the left of the stairway to the beach. The parking lot at Skyline Boulevard is behind railing at top of stairs. (Courtesy of DC/C HG, photo by Russell Brabec.)

HELPING WINGS. In 1983, Mary's Help Hospital was renamed Seton Medical Center. In June of 1985, the facility innovatively opened a helipad adjacent to the emergency department, allowing rapid transfer of trauma victims and other emergency patients to the hospital. (Courtesy of Seton Medical Center.)

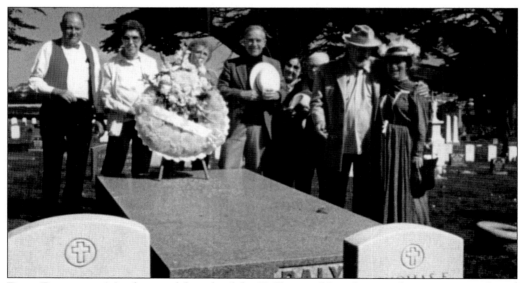

DALY DEVOTEES. Members and friends of the E Clampus Vitus historical association gathered at the grave of John Donald Daly, "The Father of Daly City," at Woodlawn Cemetery in 1986. Among those placing a commemorative floral tribute were costumed look-alikes of John and Mrs. Daly. (Courtesy of Gillespie collection.)

DALY CITY'S DIAMOND. A John Daly look-alike in a Deusenberg car was among the attractions at the diamond 75th anniversary parade celebrating the city's incorporation. Among sideline greeters after the traditional array of floats, marching bands, precision units, and decorated vehicles was Tony Giammona, then serving his fourth term as mayor. (Courtesy of Gillespie collection.)

COUNCIL CELEBRANTS. Saluting Daly City's Diamond Anniversary of incorporation at a festive black tie dinner at Lake Merced Golf and Country Club are members of the 1986 council and their spouses. From left to right are Councilman Mike Nevin and Kathie Nevin, Councilman Al Teglia, and Verna Teglia, Ruth Giammona and Mayor Tony Giammona, Buffy Tucker, and Councilman Jim Tucker, and Councilwoman Jane Powell. (Courtesy of DC/C HG.)

114

Five

THE MOUNTAIN REMAINS
1986–2003 AND BEYOND

In 1986, in celebration of its diamond 75th anniversary, Daly City again exhibited creativity with civic pride, unique style, a gala dinner, and a two-hour parade down John Daly Boulevard. Preparing for a new century, progress became imperative as concerns for increased housing, parking, services, and business opportunities became apparent. Even Robert S. Thornton's quaint 1866 residence had been destroyed to make room for an automotive business.

Daly City is now home to over 110,000 people. Even so, San Bruno Mountain remains the dominant landmark of the North County. At its summit, electronic beacon lights dance in the night skies. In the county-state park, trail treks are popular. Wildflowers bloom, bees buzz, birds chirp. Relics of the 1920 Crocker tract development have been uncovered on San Bruno Mountain's western slopes where rock steps and seating areas ascend. As they choose, Daly City's populace may still climb San Bruno Mountain to view the still remarkable, still outstanding, sunsets over the Pacific Ocean. In short, Daly City continues.

HISTORIC DAY FOR BART. City officials and well-wishers turned out for the August 14, 1986 placement of the final girder for the Daly City elevated turnback structure of the Bay Area Rapid Transit system. From left to right are BART information officer Sy Mouber; reporter Bill Hirschman; Bunny and Ken Gillespie, Daly City historians; Ted Kirschner, Colma councilman; Al Teglia, Daly City councilman; Pat Sweetland, aide to California Assemblyman Lou Papan; and Tony Zidich, Daly City treasurer. (Courtesy of Gillespie collection.)

Tomorrow's Leaders. Shown with their teachers are 1986–1987 second-grade students at George Washington Elementary School, standing tall and full of scholastic pride. (Courtesy of DC/C HG.).

Congressional Honor. Eleventh District U.S. Congressman Tom Lantos honored the memory of John Daly, for whom Daly City was named, at city hall ceremonies in 1987. Shown receiving a framed excerpt from the Congressional Record of the United States, citing Daly family history and contributions to San Mateo County, are members of the honoree's family. Holding the award is Mr. Daly's granddaughter Frances Levensaler Bishopric. No relatives of the honoree were living in Daly City at the time. (Courtesy of Gillespie collection.)

THE "OLD" CITY HALL. Wellington Avenue, between Mission Street and Irvington Street in the Crocker tract, was the site of both the first and second city hall buildings. This view of the second seat of local government, completed in 1939, was taken in 1988 just before the building was demolished for construction of condominia. An entrance plaque, placed by the Native Sons of the Golden West on May 31, 1939, was preserved. It proclaimed "This building dedicated to Truth, Liberty, Toleration." (Photo by Ken Gillespie.)

WHERE DALY CITY STARTED. Preparing a commemorative plaque are Daly City historians Ken and Bunny Gillespie with Eugene Fambrini (center) at the pioneer Colma monument shop of Donohoe & Carroll. The etched granite rectangle reads: "Near this site from 1868-1907 was the 250 acre San Mateo Dairy ranch operated by pioneer resident John Donald Daly, for whom Daly City was named upon incorporation of the city in 1911. Among his philanthropic gestures was the opening of his Daly's Hill property to refugees of the disastrous 1906 San Francisco earthquake and fire. Dedicated by Yerba Buena Chapter No. 1, E Clampus Vitus, and Crocker Lodge No. 454 F. & A.M." (Courtesy of Gillespie collection.)

CLAMPER "DOINS." Members of E Clampus Vitus historical society listened to Bob Greenstrand, Worshipful Master of Crocker Lodge #454 Free and Accepted Masons, as he prepared to unveil a plaque to be affixed to the north wall of the Crocker Masonic Temple, 17 Hillcrest Drive, on April 8, 1989. The marker notes "Where Daly City Started." (Courtesy of Gillespie collection.)

FIRST "SKYSCRAPER" OFFICE BUILDING. Rising seven stories and including a penthouse, the J.S. Building at 2169 Junipero Serra Boulevard was the first "high-rise" building constructed in the redevelopment area. Groundbreaking was July 13, 1988. Finished in timely fashion, the grand opening was November 15, 1989. (Courtesy of Gillespie collection.)

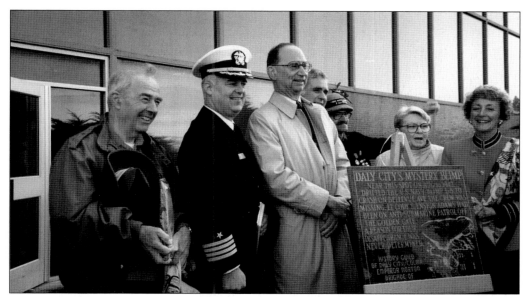

MYSTERY BLIMP PLAQUE. Blimp buffs and historians gathered at the Daly City War Memorial Building on Mission Street on January 9, 1993, to dedicate a marker commemorating the 1942 crash of a U.S. Navy blimp on Bellevue Avenue. From left to right are Ken Gillespie, historian; Capt. Victor Dodds, San Francisco Naval Base; California State Senator Quentin Kopp; Mayor Albert Teglia; Geno Fambrini, ex-Noble Grand Humbug of E Clampus Vitus; Councilwoman Jane Powell; and San Mateo County Supervisor Mary Griffin. The plaque was placed on an inside wall of the War Memorial Building. In May 1993, the network TV program *Unsolved Mysteries* did a 20-minute segment on the blimp incident. (Courtesy of Gillespie collection.)

TITLE HOLDERS. Four former Miss Daly City title holders were reunited in 1996 at a history evening program sponsored by the History Guild of Daly City/Colma. From left to are Diane Wagner, Miss Daly City for 1971 and Miss California in 1972; Dorothy Barragan, Miss Daly City for 1978; Diane Albee, Miss Daly City for 1976, and Lynette Fischel, Miss Daly City for 1961. From 1955 through 1983, selection of Miss Daly City was a project of the DC/Colma Chamber of Commerce. (Courtesy of Gillespie collection.)

VINTAGE DISCOVERIES. More than 100 years after metal track was laid on Mission Street for the passage of streetcars through Daly City, work crews uncovered original pieces of rail. Street work halted briefly to allow gathering of some of the vintage materials for preservation at the DC/C HG's mini-museum. (Photo by Ken Gillespie.)

THE CHANGING SCENE. The Serra Theater on El Camino Real near Eighty-eighth Street had been closed to movie goers for decades when this photo was taken in July 1999. In recent years, the lobby had hosted the Serra Coffee Shop. The lower floor was used for storage. In preparation for demolition of the building and construction of the Hampton Inn, the final letter of the logo name was the first item to be removed from the façade. Council members took sledge hammers to the base of the ticket booth that fronted the entrance. (Courtesy of Gillespie collection.)

J.D.D. Look-Alike. Ed Crary, great grandson of John Donald Daly, posed in 1999 near his famous ancestor's photo at the mini-museum of Daly City history maintained by the History Guild of Daly City/Colma at 40 Wembley Drive. The large portrait had been given to the Guild by McDonald's Restaurant on Mission Street when that facility changed its interior décor. (Courtesy of Gillespie collection.)

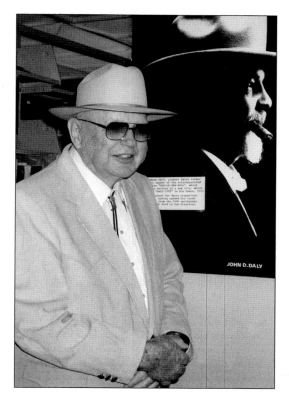

Newest School Building. Opened in 1999, the Susan B. Anthony Elementary School continues Jefferson School District's 150-year tradition of providing education for Daly City and Colma children. (Courtesy of DC/C HG, photo by Frank Franceschini.)

PACIFIC PLAZA PLEASURES. Century Theatre became a landmark of the new century when it opened as part of the huge Pacific Plaza multi-use complex at 1901 Junipero Serra Boulevard High-rise office buildings, restaurants, and parking facilities surround the theater. (Courtesy of DC/C HG, photo by Frank Franceschini.)

HISTORY AL FRESCO. Presenting displays of historical memorabilia wherever invited, members of the History Guild of Daly City/Colma enjoy a day in the sun at San Mateo Park. From left to right are Walter Schultz, Al Teglia, Ken Gillespie, and Betty Schultz. Guild exhibits have also graced Colma's Noodle Fest and Daly City's Gateway Festival. (Courtesy of Gillespie collection.)

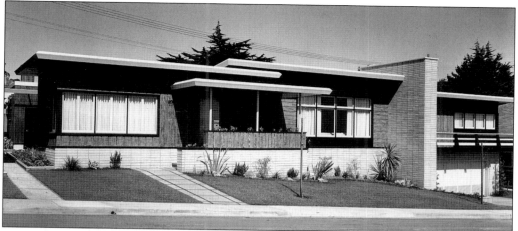

HENRY'S HOUSE. When this landmark Daly City home at 112 Northgate Avenue (in Westlake) went on the market in 2002, promotional material invited potential buyers to "own a piece of history." The asking price was $1,250,000. Custom-built a half-century earlier for Henry Doelger, the developer of the Westlake section of Daly City, the residence boasted six bedrooms, four and a half bathrooms, and a five-car garage. Other amenities included a spacious atrium with an indoor swimming pool plus "a great view of the fairways of the world-famous Olympic Golf Club of San Francisco." (Courtesy of DC/C HG, donated by Doelger Estate.)

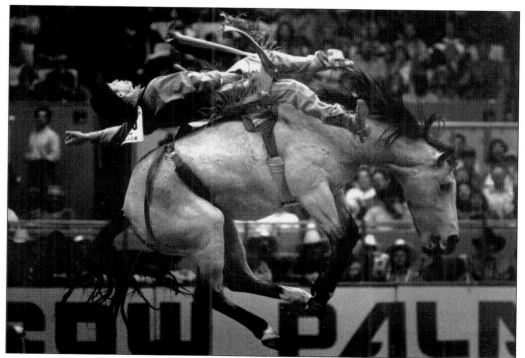

RIDE 'EM COWBOY. This 2002 photo is typical of the Old West action that takes place at the Cow Palace on Geneva Avenue each fall as the Grand National Rodeo, Horse Show, and Livestock Exposition continues a tradition started in 1941. Over the years, more than six million people passed through Grand National turnstiles. (Courtesy of DC/C HG, donated by the Cow Palace.)

JEFFERSON REMODELED. Dating back to 1922, Daly City's first high school, Jefferson, has grown from one small building to a 20-acre campus. The school received a makeover at the end of the 20th century to achieve this modern look. Jefferson's popular Indian logo in blue and yellow decorates the tower structure and base of the flagpole. Long gone is the original ornate Mission-style building with semi-circular driveway fronting the building. (Courtesy of DC/C HG, photo by Frank Franceschini.)

ARCHITECTURAL GEM. "A sweeping monument, crowned by its barrel-vaulted gymnasium," as it was described, Westmoor High School on Eastmoor Avenue was a challenge for master architect Mario J. Ciampi but won him a national architectural award. Ciampi was commissioned to design Westmoor in 1950. Population growth forced delays as student capacity requirements went from 600 to three times larger. This 2002 image shows Westmoor in updated green and white exterior colors. (Courtesy of DC/C HG, photo by Frank Franceschini.)

TODAY'S LEADERS. Members of the Daly City Council for 2002–2003 were chosen by the city's electorate, representing a population numbering well over 110,000. Shown from left to right are Councilman Michael "Mike" Guingona, Mayor Adrienne Tissier, Councilwoman Carol Klatt, Councilman Sal Torres, and Councilwoman Maggie Gomez. (Courtesy of Daly City City Hall.)

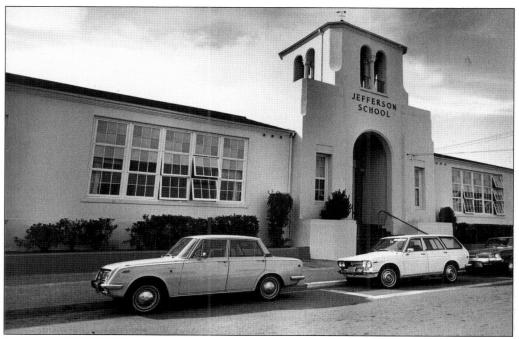

PERPETUATING THE NAME. Built in 1934, Jefferson School, at 14 Alemany Street, now houses district archives. (Courtesy of DC/C HG, photo by Frank Franceschini.)

THORNTON OVERVIEW. Just over 150 years ago, Robert S. Thornton spurred his horse along the sandy shore of the Pacific Ocean to settle on land that eventually became Daly City. Plans call for development of a cliffside location into a public viewpoint of Thornton State Beach, complete with walking paths and historical-geological signage. (Courtesy of Gillespie collection.)

CANYON PARKWAY. Winding east from Daly City, Guadalupe Canyon Expressway offers uniquely beautiful scenery and convenience. The road provides access with Bayshore Highway after passing close to the base of Antenna Hill and near the entrance of San Bruno Mountain County-State Park. (Courtesy of DC/C HG.)

126

Towers atop the Mountain. Visible for many miles, towers at the peak of San Bruno Mountain serve as communications transmitters as well as illuminated beacons. Their lights provide pleasant twinkles of red and white against night skies. (Courtesy of DC/C HG.)

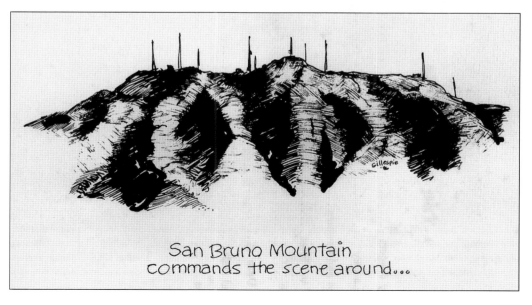

San Bruno Mountain
commands the scene around...